CREATING FANTASY ART

Draw Your Own Awesome Heroes and Villains

STEVE SIMS

ARCTURUS

This edition published in 2010 by Arcturus Publishing Limited
26/27 Bickels Yard, 151–153 Bermondsey Street,
London SE1 3HA

Copyright © 2010 Arcturus Publishing Limited

ISBN: 978-1-84837-493-5
CH001251EN

Printed in Singapore

CONTENTS

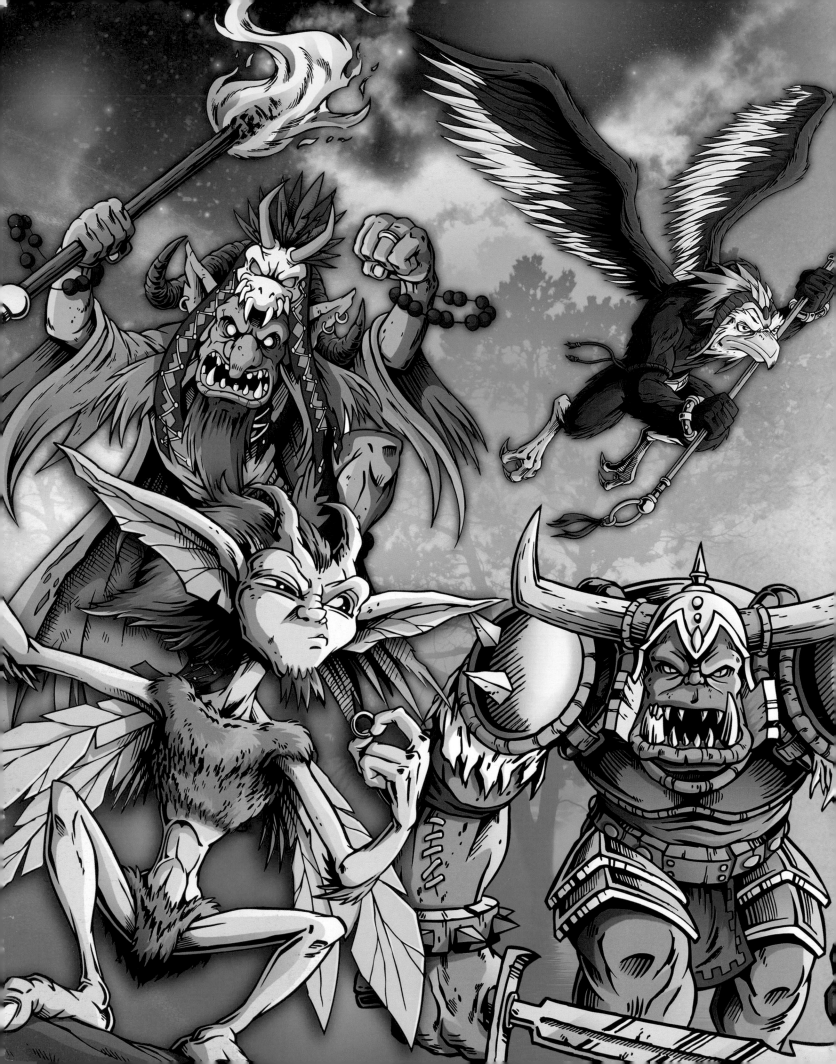

Introduction

In this book, expert illustrator Steve Sims teaches you to draw 18 awesome fantasy characters including brave heroes, magical creatures, sneaky assassins and wicked rulers. Each character is broken down into clear, easy-to-follow drawing steps, so you'll soon see your characters come to life on your drawing pad!

Before you get stuck in to drawing the characters, we've included an opening section that's packed with useful hints and tips to get you started. You'll find advice on which drawing tools to use, and helpful ideas on how to construct your characters by layering basic shapes.

And that's not all! At the end of each chapter there's a page with handy drawing tips and ideas on how to add extra special touches that will bring your illustrations to life.

So, get ready to put pencil to paper and immerse yourself in the world of fantasy art, where the only limit is your imagination!

DRAWING TOOLS

Let's start by looking at the tools of the trade you'll need to create your own awesome fantasy characters. Invest in the essentials and then build up your collection of drawing tools over time.

LAYOUT PAPER

There are so many different types of paper that, at first glance, it can seem difficult to know which is best for your drawings. It's always a good idea to start with a basic, inexpensive paper while you experiment with the different features of your characters. When you have something that you are happy with, you could move on to a heavier, higher quality paper for your final version.

WATERCOLOUR PAPER

This type of paper is useful if you are planning on colouring your finished drawings using water-based paints. It is made from 100 per cent cotton and comes in a variety of weights and textures – 300 gsm (grams per square metre) or above is best.

CARTRIDGE PAPER

This top quality paper is the type that's most frequently used for illustration and drawing and is ideal for your final version. You don't need to buy the most expensive brand to get great results.

PENCILS

Most of your work will be done in pencil, so it is a good idea to make sure you are comfortable with the type of pencil you choose. Graphite (lead) pencils come in various grades and are marked 'B' for blackness, or 'H' for hardness. A 2H is a good mid-range pencil to start with as it leaves clean lines and few smudges.

From here you can experiment with slightly blacker, or harder, pencils until you find one you are happy with. A lead-holder pencil, or technical pencil, is also a good idea as this can help you get finer, more accurate lines, and the lead breaks less than with a traditional pencil.

ERASER

Erasers come in three types: rubber, plastic and putty. All three are effective, but rubber ones are the most common type to start with.

DRAWING TOOLS

PENS

The most important thing to consider when choosing your pen is how you are planning on colouring your artwork. If you intend to use water-based paints, then you must make sure that you use a waterproof ink pen, to prevent the ink from running as you colour. The next thing to consider is the thickness of your pen and the inking effect you want to achieve. Most pens have their nib thickness marked on the lid, ranging from 01 (0.1 mm) to 05 (0.5 mm). Pens with 02 or 03 nib thickness are good all-rounders. An 01 pen is very thin and ideal for fine, intricate details.

BRUSHES

Another way to ink your work is with a fine brush. This method is more difficult to master, as it requires a very steady hand, but the results can be very effective. If you fancy giving it a try, invest in a good quality sable brush.

PAINTS

Most art shops will stock a variety of different paints that you could use to colour your artwork. Acrylics, watercolours, oils and gouache are just a few of the types available. Experiment with different types of paint until you find one that you are confident with, and gives you the effect that you are looking for.

COMPUTER

Another way to colour your artwork is to scan your inked illustrations and then colour them digitally. Programmes that allow you to create layers are useful for building depth and tone into your colouring.

DRAWING TIPS : HUMAN FIGURES

Learning how to draw human figures is a good place to start. You might not have any reference for how an orc's or a goblin's frame is formed, but you can look in a mirror to see a human's structure!

1 Start by drawing a basic wire frame. Mark in the main joints using circles, and roughly add the hands and feet.

2 Build on your frame using basic shapes such as cylinders, spheres, cubes and rectangles. As you add them to your wire frame you can start to see your figure taking shape. From here, draw a smooth outline around the shapes to flesh out your figure.

TOP TIP !

Most adult human figures are seven times the height of their head. Draw your character's head, then calculate his or her height by measuring one for the head, two heads for the upper body, three for the legs and lower body, and one for ankles and feet.

HUMAN HEIGHT = 7 HEADS

3 When you're happy with your basic pencil drawing, it's time to bring your character to life by adding fine details, followed by ink and final colour.

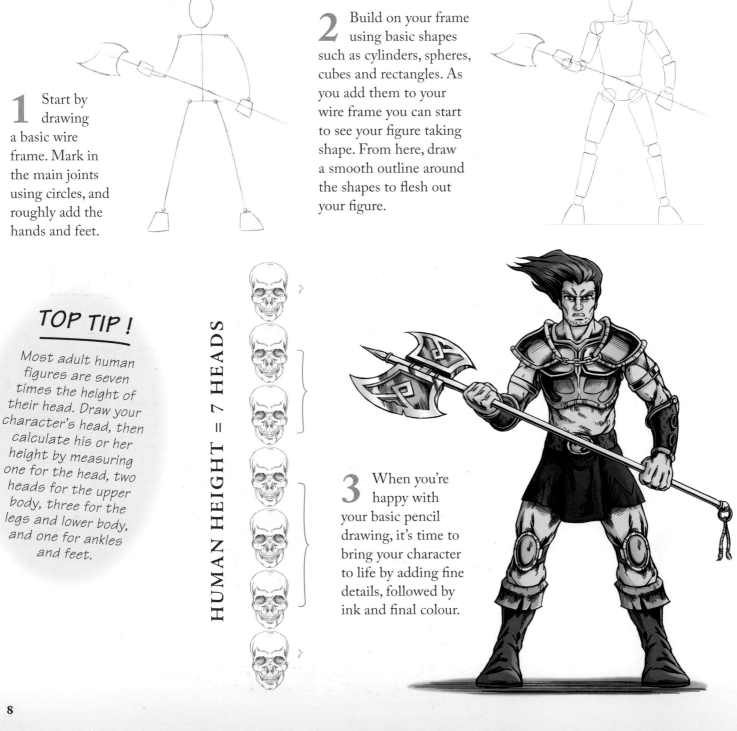

DRAWING TIPS : HUMAN FIGURES

1 Female figures are created in exactly the same way. Draw your basic wire frame, seven heads high, but remember that a female head is slightly smaller than the male's – unless you're drawing a giant woman!

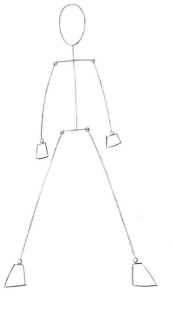

2 When adding your construction shapes remember to give your woman a slimmer waist and a slighter build. Bear in mind that with both male and female characters the hands should fall at the top of the thighs.

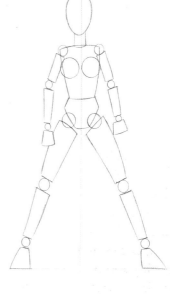

HUMAN HEIGHT = 7 HEADS

3 When adding detail to your female characters, almond shaped eyes, fewer muscles and long, flowing hair will add instant femininity.

TOP TIP !

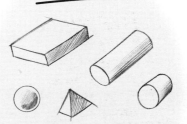

All figures can be constructed using these basic geometric shapes.

DRAWING TIPS : MONSTERS AND BEASTS

So, who's the biggest, tallest and toughest of them all?
Let's see how these fantasy creatures measure up against their human counterparts.

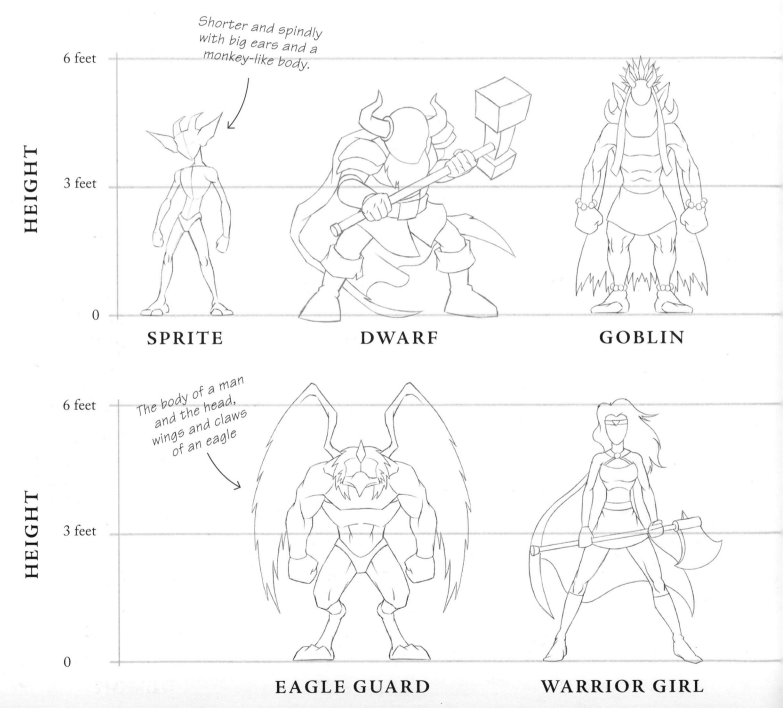

Shorter and spindly with big ears and a monkey-like body.

The body of a man and the head, wings and claws of an eagle

HEIGHT

6 feet

3 feet

0

SPRITE DWARF GOBLIN

HEIGHT

6 feet

3 feet

0

EAGLE GUARD WARRIOR GIRL

DRAWING TIPS : MONSTERS AND BEASTS

The great thing about fantasy art is the only limit is your own imagination!
Have fun inventing new characters by experimenting with human, animal and monster forms.

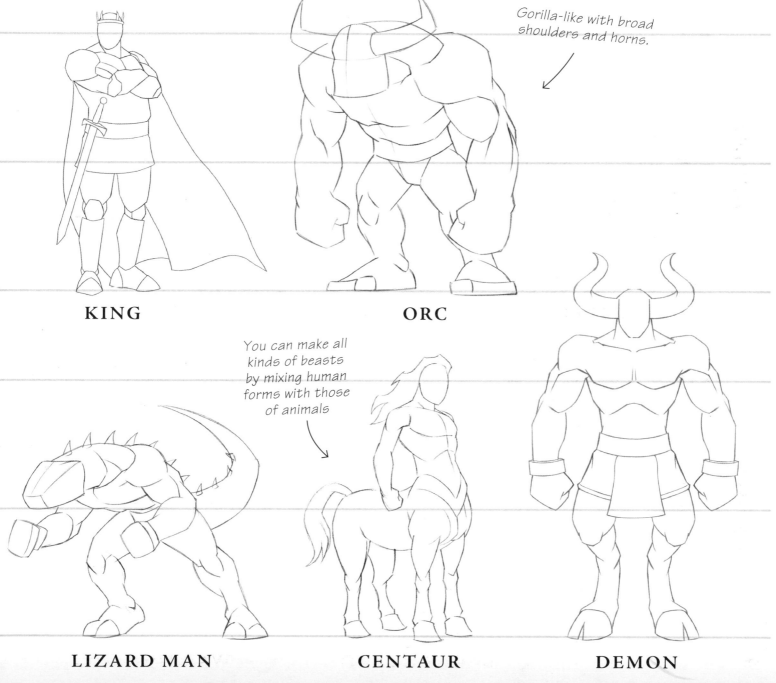

Gorilla-like with broad shoulders and horns.

You can make all kinds of beasts by mixing human forms with those of animals

KING

ORC

LIZARD MAN

CENTAUR

DEMON

INKING TIPS

Sketching and building your character can involve a lot of corrections, so don't worry if your pencil drawings look a bit messy and smudged. When things are looking good, and your character is complete, then it's time to ink it.

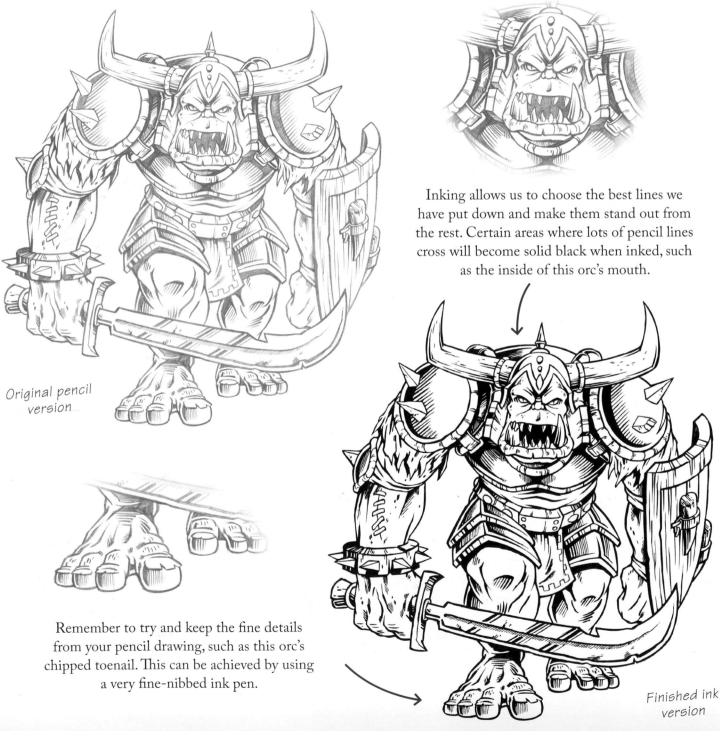

Inking allows us to choose the best lines we have put down and make them stand out from the rest. Certain areas where lots of pencil lines cross will become solid black when inked, such as the inside of this orc's mouth.

Original pencil version

Remember to try and keep the fine details from your pencil drawing, such as this orc's chipped toenail. This can be achieved by using a very fine-nibbed ink pen.

Finished ink version

COLOURING TIPS

After the inking stage, it's time to colour your characters. Start by applying your base tones and then build up your colour by layering other shades on top. Experiment with pens, pencils, and paints until you achieve the desired result.

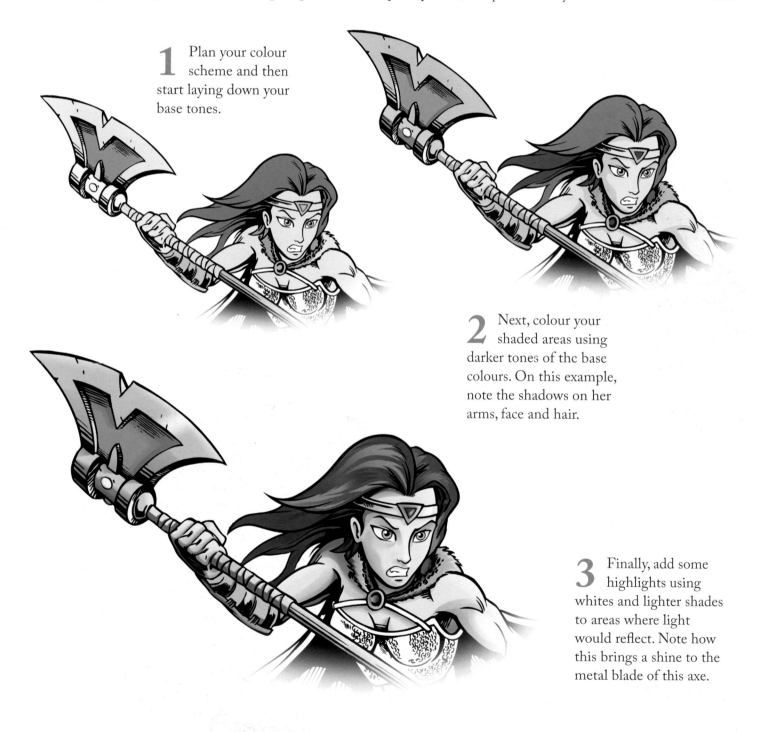

1 Plan your colour scheme and then start laying down your base tones.

2 Next, colour your shaded areas using darker tones of the base colours. On this example, note the shadows on her arms, face and hair.

3 Finally, add some highlights using whites and lighter shades to areas where light would reflect. Note how this brings a shine to the metal blade of this axe.

The Good Army

These characters are heroes, the brave warriors who fight for the forces of good and the protection of others. They rush into battle without a second thought for themselves in order to preserve what they believe in. When drawing these heroes make sure you give them sturdy armour – more often than not they're going to need it!

MALE WARRIOR

This highly trained warrior is a fearless protector of the lands of light, who fights with unrivalled fury to uphold all that is good. All weapons are deadly in his hands and all opponents shall fall at his feet.

1 Start by drawing your basic frame. The male warrior is ready to attack, in this aggressive action pose.

MALE WARRIOR

2 Warriors are tough fighting machines with broad shoulders and legs, so build on your wire frame with some hefty blocks as a base for all those muscles.

3 Once you have all of your basic shapes in place, draw around them to give your figure a smooth outline. At this point you can erase your wire frame. Pencil in your warrior's hair and the shape of his sword.

MALE WARRIOR

4 When you're happy with the outline of your figure, erase all of your basic shapes so that you have a clean pencil drawing. Now you can start adding detail. Mark in your warrior's clothing, leather arm cuffs, shield and dagger. Give him a determined, battle-ready expression, a furrowed brow and an open, yelling mouth that will strike fear into the hearts of all who stand in his way!

5 This is your final pencil stage, so it's time to add all of the fine details. Note the worn look of his wooden shield, the detail on his weapons and the muscle tone on his skin. Before you ink your character, plan the areas where light hits your figure, and add shading to places that are in shadow.

TOP TIP !

To make your warrior look really battle-hardened add a few scars and wounds from previous battles.

6 Now ink your character, going over your best pencil lines. Add darker, solid ink to the areas that are in shadow, which will add depth to your figure.

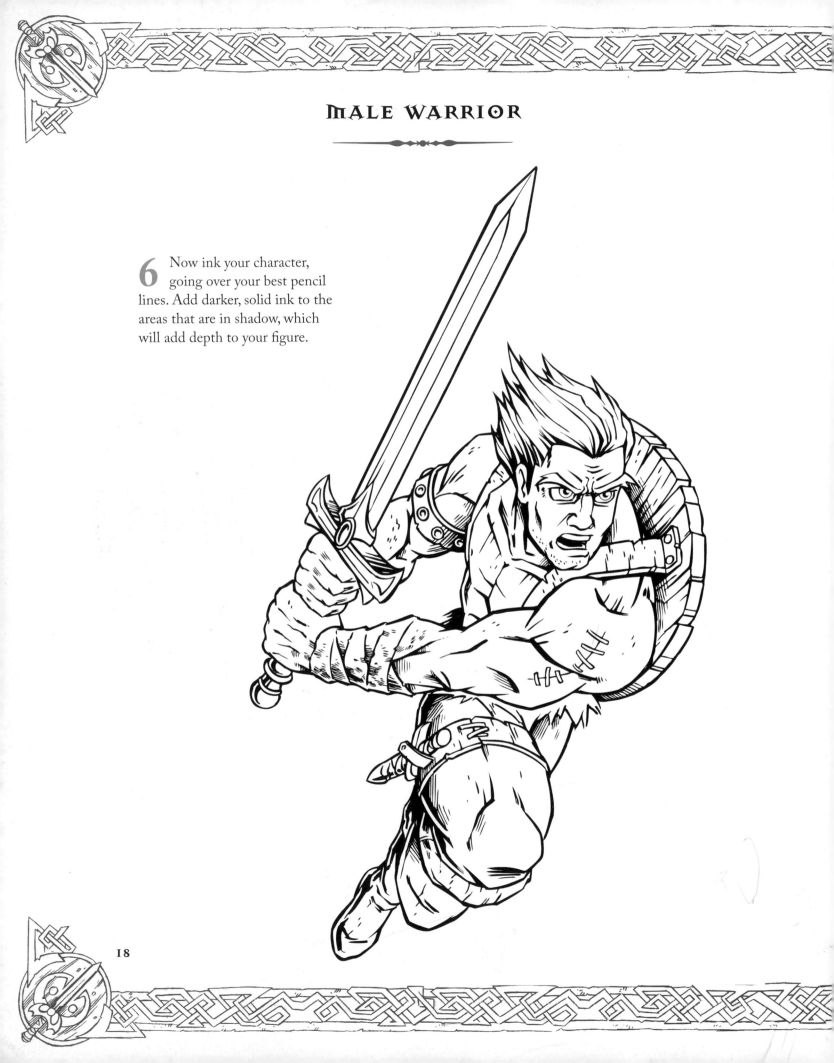

MALE WARRIOR

7 The final step is to colour your warrior. Try to use shades that will enhance the different textures in the image. Use a bright yellow-gold for his metal sword, and muted browns for his wooden shield and leather boots. Use white to highlight where the light shines on his shield, and the areas where it hits his body.

FEMALE WARRIOR

Loyal to her king, this agile fighter
charges into battle with the ferocity
and heart of a warrior twice her size,
fighting for the forces of good. Many
have judged her by her size,
and many have not lived to
do so again.

1 Start by creating a strong
action pose with your wire
frame. The female warrior's
body is angled to the side of her
leading leg, while her other leg is
bent up behind her as she runs.

FEMALE WARRIOR

2 Build around your frame using basic shapes. Try to keep the curves of the body as fluid as possible to create a sense of movement.

3 Once you can see your figure taking shape, remove your wire frame and draw around the shapes to create your outline. Start to add her clothing and hair.

FEMALE WARRIOR

4 Erase all of your basic shapes so that you're left with a clean pencil outline, then start adding detail. Give her some body armour and finalise her clothing, adding a cloak and boots. Give her expression as much attitude as you would a male warrior, but draw almond-shaped eyes, a smaller nose, and hopefully less stubble!

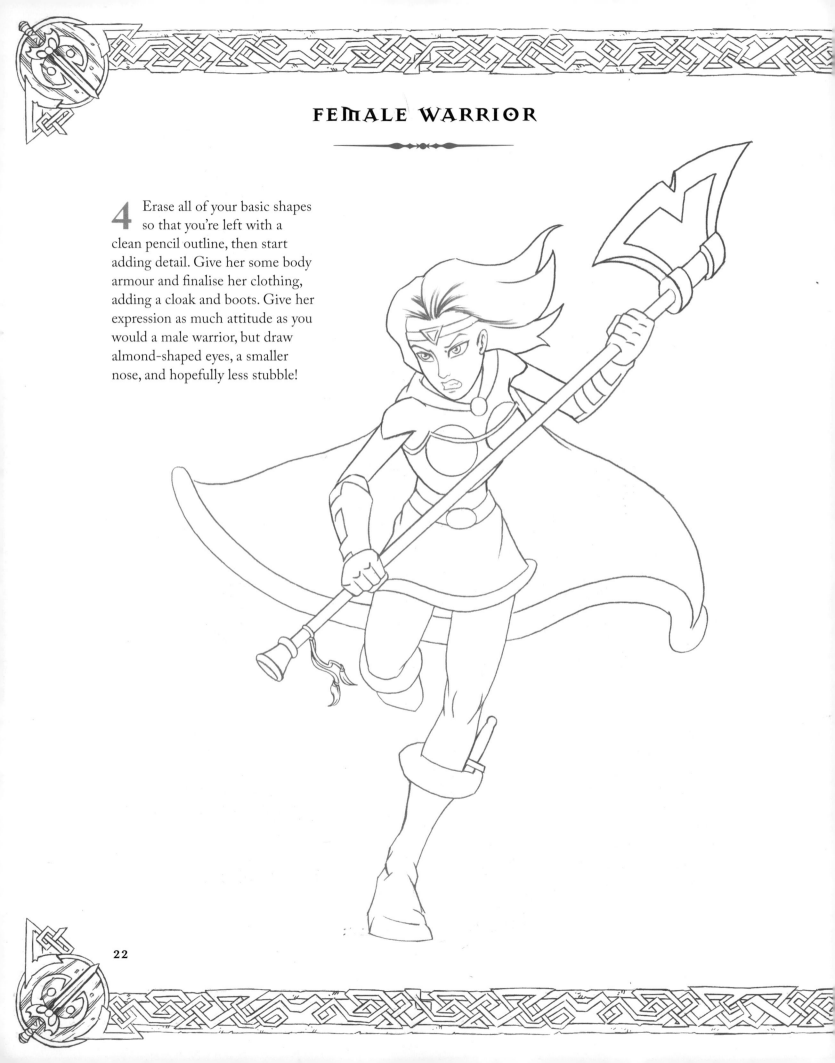

FEMALE WARRIOR

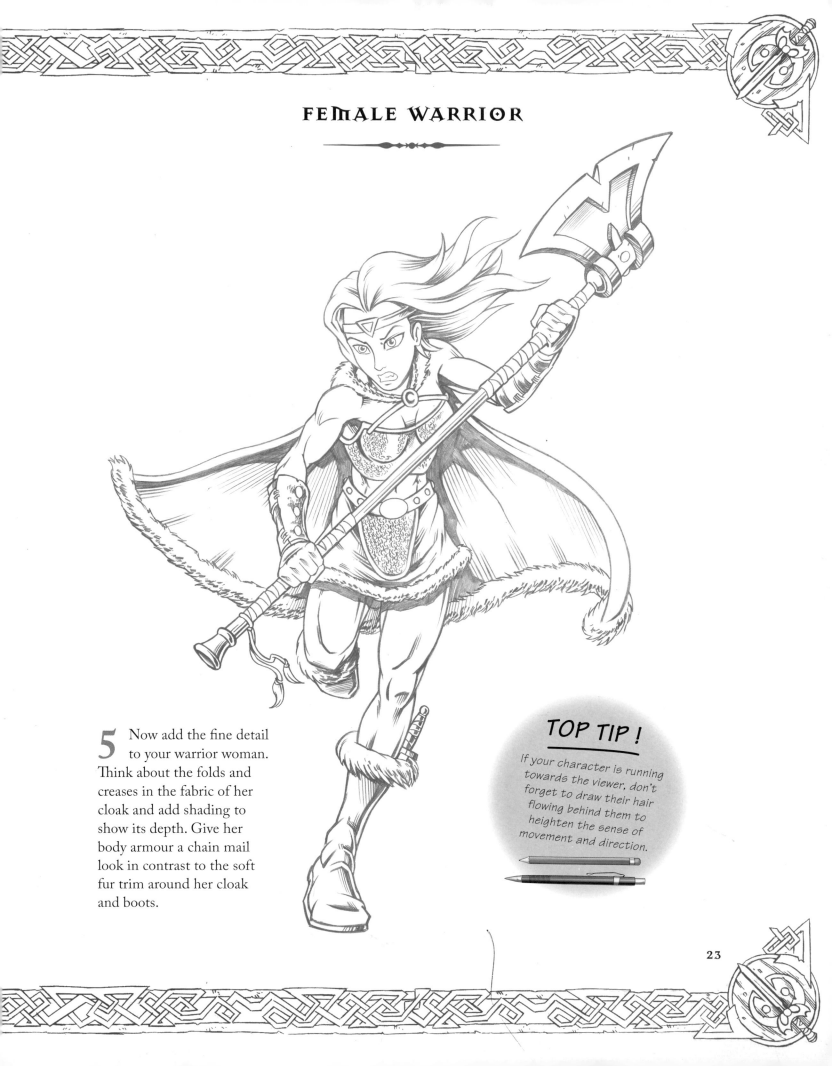

5 Now add the fine detail to your warrior woman. Think about the folds and creases in the fabric of her cloak and add shading to show its depth. Give her body armour a chain mail look in contrast to the soft fur trim around her cloak and boots.

TOP TIP !

If your character is running towards the viewer, don't forget to draw their hair flowing behind them to heighten the sense of movement and direction.

FEMALE WARRIOR

6 When inking your character try to keep as many of the fine, detailed lines from your final pencil drawing as you can. Use heavier lines to define muscle tone, and solid areas of black ink to add depth.

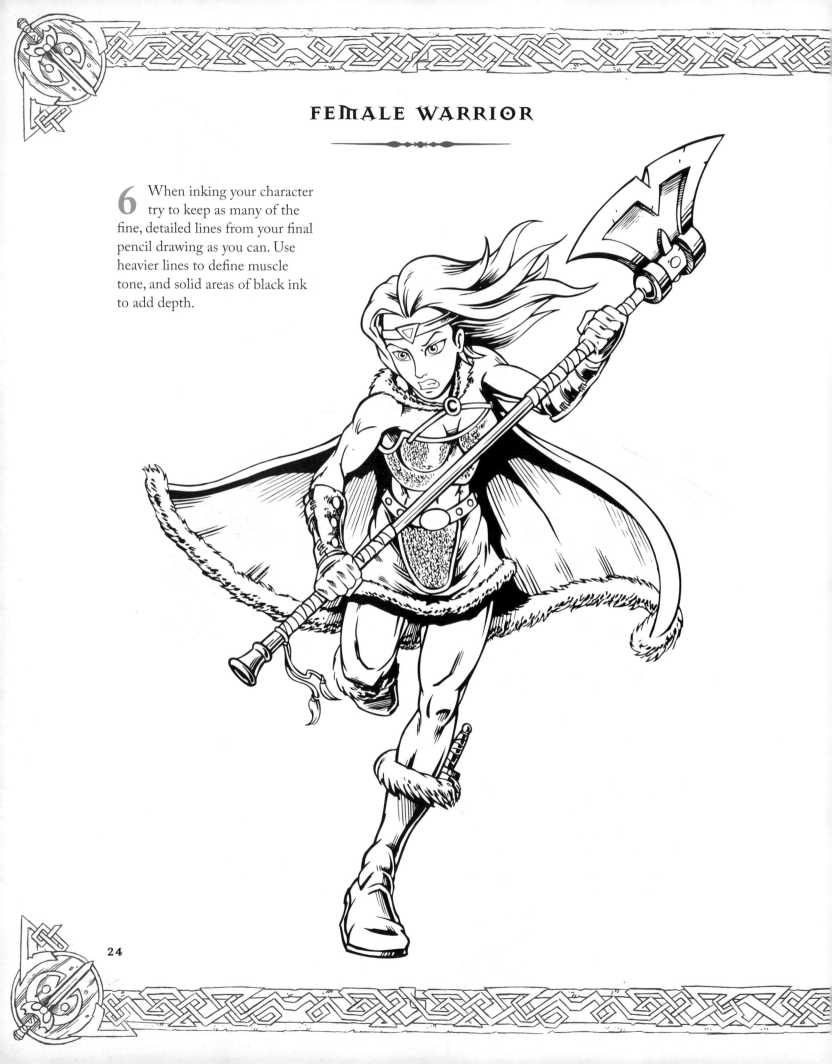

FEMALE WARRIOR

7 Now it's time to colour
your character. Keeping
your colour palette simple, then
adding flashes of bright colours
can be very effective. Shades of
grey work well for her armour
and weapon. Remember to add
highlights to give the metal a
reflective quality.

DWARF WARRIOR

From the stone kingdom of the western
mountains comes this mighty warrior.
Armed with incredible strength and
determination, this dwarf likes nothing
more than seeing evil fall beneath
the power of his ancient hammer.

1 Start by drawing the
basic stick figure. The
dwarf warrior's body is short
and stocky, and he is ready
for battle.

DWARF WARRIOR

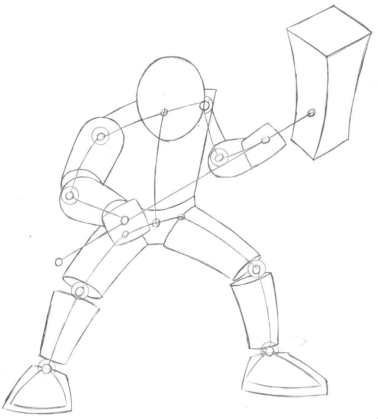

2 Build on your frame by adding basic shapes. Use thick, short cylinders to form his legs and arms, then add a rectangular block as a base for his hammer.

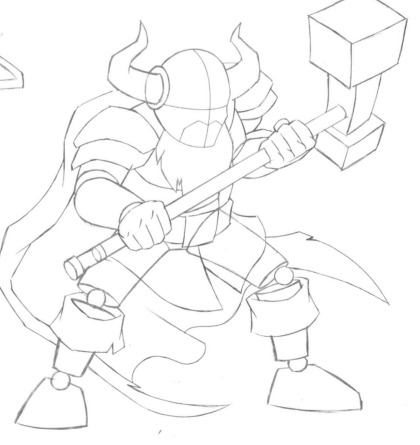

3 Keep building on your figure, removing your stick figure lines as it takes shape. The dome of his head will form the basis for his helmet. Add the horns on either side. Mark in his beard, clothing, boots and armour. Flesh out his hands and arms, and use blocks to divide his hammer's head into sections.

DWARF WARRIOR

4 Finalise your pencil drawing, erasing your construction shapes as you go along. You now have the basis of a pretty tough warrior. Start adding the finishing touches like all the creases in his clothing and the detail on his helmet. Give him a determined, battle-ready expression.

DWARF WARRIOR

5 Clean up the lines you have drawn and then add in all your final detail and shading. This will really bring your dwarf warrior to life.

TOP TIP !

Small details such as chips and cracks will help to make a weapon look old and battle-hardened.

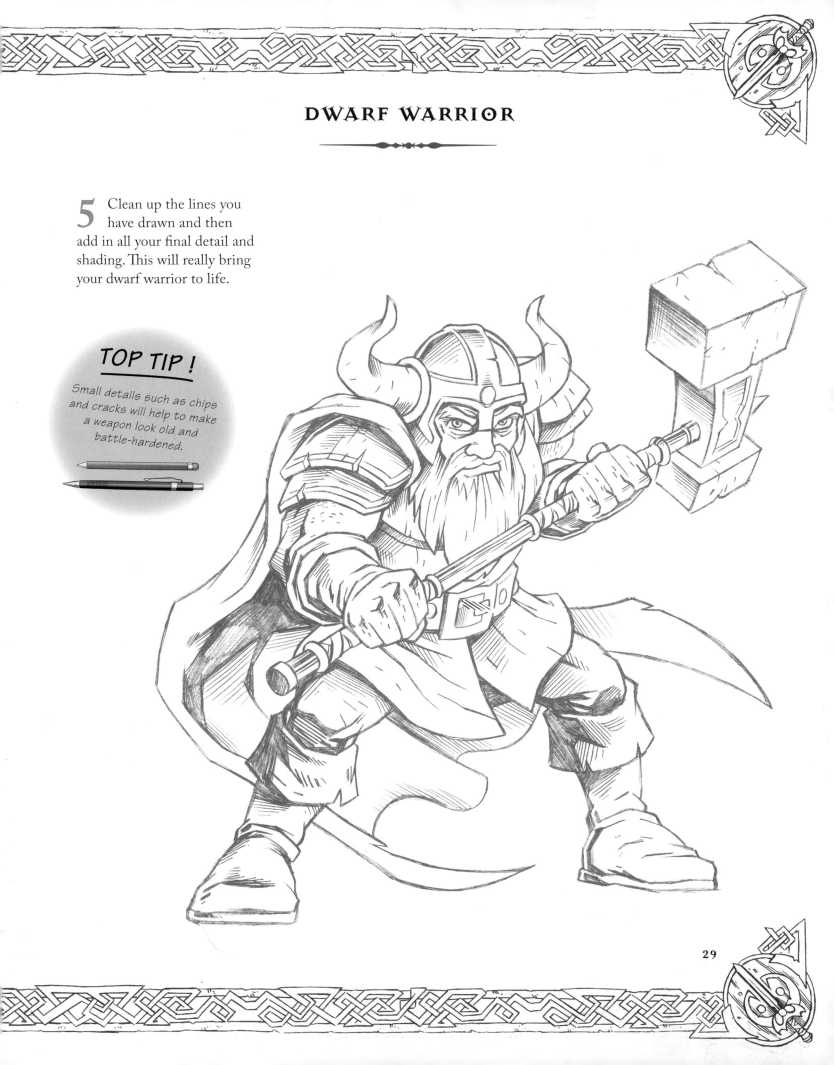

DWARF WARRIOR

6 Now you have everything in place, it's time to ink over your final pencil lines. Try to keep lots of the fine detail, like the chips and battle damage to his weapon and armour plating.

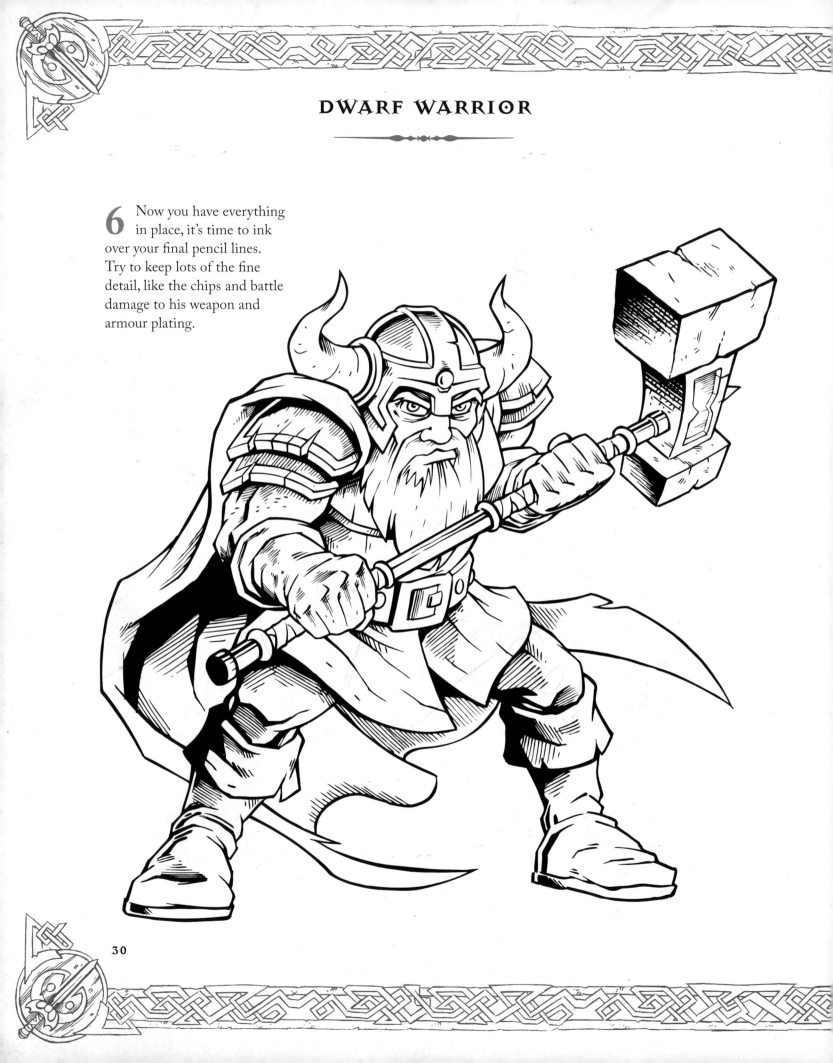

DWARF WARRIOR

7 The final step is to colour your warrior, which will really bring him to life. He is a brave and strong character, so rich colours will add a sense of heroism to his outfit. Give him a white beard and don't forget to add highlights to his shiny, metal armour.

Movement and Combat

Once you are more confident with the basic construction of human characters, start experimenting with the way figures move. Try putting them in different action poses with different props and weapons.

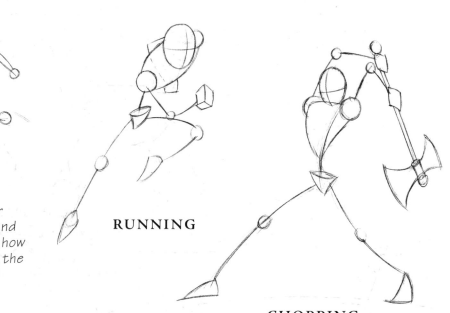

POWER KICKING

Looking at people in motion, or photographs of people running and jumping, will help you understand how their limbs are positioned during the different actions.

RUNNING

CHOPPING

Drawing two characters fighting isn't as hard as it might seem at first. Follow the same steps that you would to create one character, just do it with two!

1 Draw the basic frame of one character first, and then the frame of his or her opponent. Build on the frames using your basic shapes, remembering how perspective will work on your characters, and that their sizes might differ depending on what sort of creature they are.

Movement and Combat

2 Progress through the drawing stages as you would normally, deleting your frame lines and basic shapes as you go along.

3 When you come to add final details and colour to your charcters, try adding some special effects. The reflection of light where a sword hits a shield or the cloud of dust where a fallen warrior hits the ground will really animate your scene.

The Dark Army

These characters are the bad guys that you wouldn't want to meet on a dark night. They are villains who work to spread evil, either for their own gain, or that of a malevolent master. When you draw each member of the dark army, try to display their wicked nature in their outfits, weapons, and fiendish expressions.

ORC WARRIOR

The orcs form an impenetrable wall of pure power and brutality, making them the dark lord's deadliest weapons. Brandishing fierce weapons, they march into battle with an unstoppable fury, allowing nothing to stand in their way.

1 This orc is a walking powerhouse. Start by drawing a wide, slouching frame from which to hang some huge muscles.

ORC WARRIOR

2 Build his body using basic shapes, but remember to make his chest, shoulders and arms bigger than that of a normal man – this is one big dude!

3 Once you have the basic outline in place, remove your frame and construction shapes. Now it's time to develop specific areas of interest, namely the orc's big muscular arms, his horns that protrude through his helmet and his big lumbering feet. Also pencil in his shield and sword.

4 Add in your orc's helmet, chest plate, shoulder guards and cuff. Pencil in his face, remembering that orcs have small features and beady eyes, but big, powerful jaws and teeth. This brute has a broken tooth from a battle.

TOP TIP !

Add horns, spikes and extra pointy bits to make sure your characters' armour looks as intimidating as their weapons.

ORC WARRIOR

7 Once you're happy with the inking it's time to add colour to your character. Muted, earthy colours are the best choice for orcs. Use a dull grey for his body armour and choose a sandy brown for his skin.

GOBLIN ASSASSIN

The goblin assassin is an evil, calculating warrior who hides in the shadows waiting for the moment to deliver a fatal attack. Hardly noticeable within the chaos of the battlefield, he only reveals himself to his victim as he delivers a deadly strike.

1 It's time to tackle the sneakiest goblin of the lot. Start with your usual wire frame, drawing the character in a crouching pose with one leg outstretched. Our character should be leaning low and ready to strike at any moment.

2 Fill out the frame with the basic shapes and add the swooping line of the assassin's chain.

GOBLIN ASSASSIN

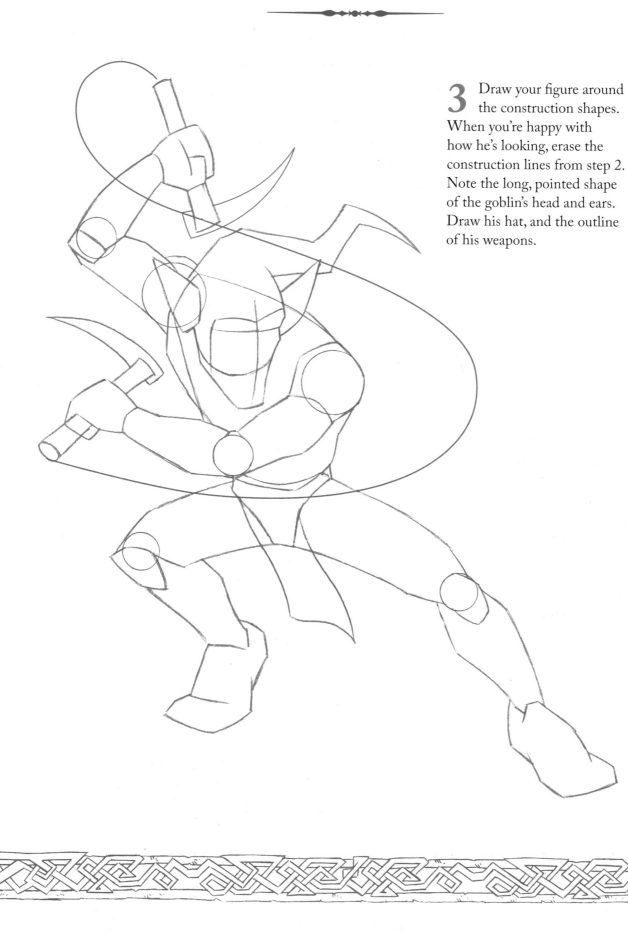

3 Draw your figure around the construction shapes. When you're happy with how he's looking, erase the construction lines from step 2. Note the long, pointed shape of the goblin's head and ears. Draw his hat, and the outline of his weapons.

GOBLIN ASSASSIN

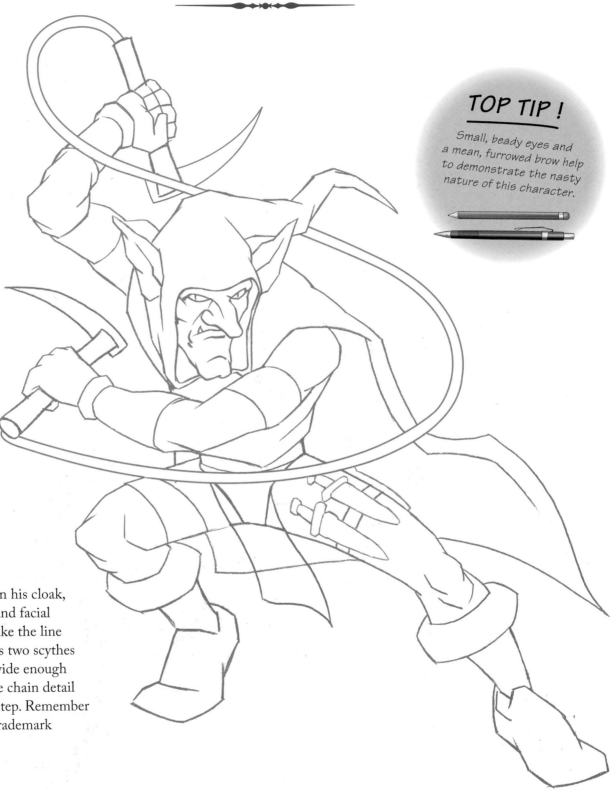

TOP TIP !

Small, beady eyes and a mean, furrowed brow help to demonstrate the nasty nature of this character.

4 Mark in his cloak, boots and facial features. Make the line that joins his two scythes (weapons) wide enough to add in the chain detail in the next step. Remember to add the trademark goblin nose!

GOBLIN ASSASSIN

5 Now add all the final details. Pay attention to the chain joining his weapons. Take your time and draw the links one after the other. Use the lines you have drawn in step 4 to guide the path of the chain.

GOBLIN ASSASSIN

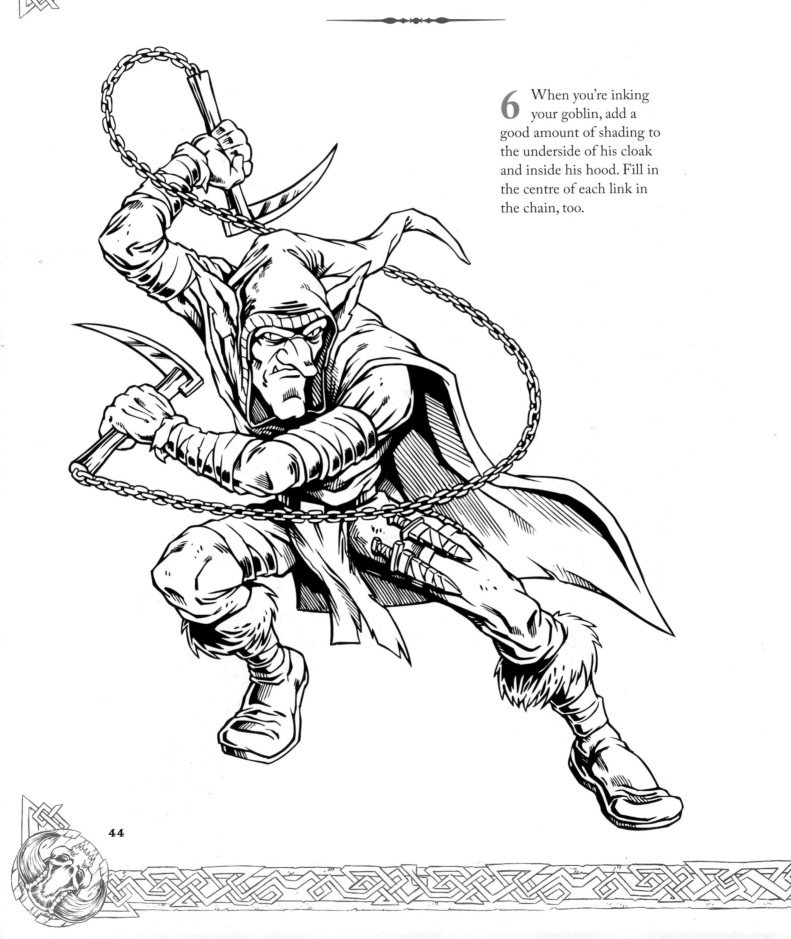

6 When you're inking your goblin, add a good amount of shading to the underside of his cloak and inside his hood. Fill in the centre of each link in the chain, too.

GOBLIN ASSASSIN

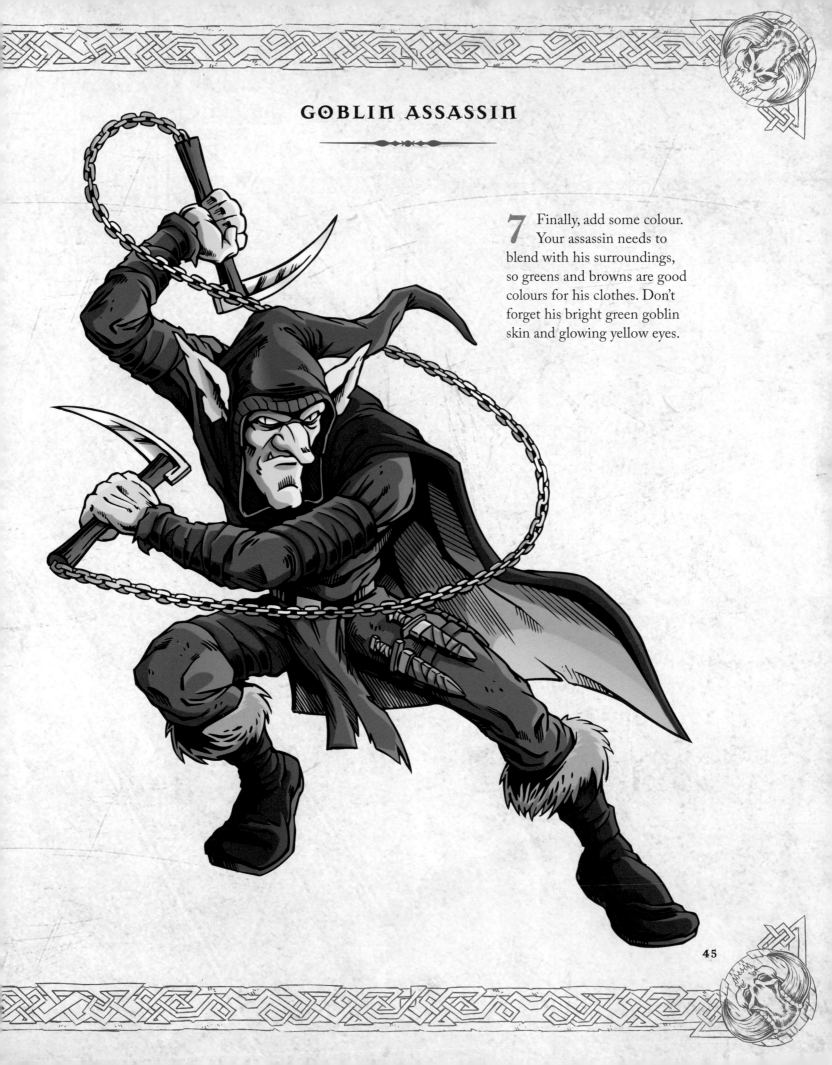

7 Finally, add some colour. Your assassin needs to blend with his surroundings, so greens and browns are good colours for his clothes. Don't forget his bright green goblin skin and glowing yellow eyes.

EVIL WIZARD

Practising the dark arts for hundreds of years has taken its toll on this evil wizard's physical appearance. In return, he has built up immense magical powers and the ability to wield the deadliest of dark spells.

1 We want our wizard to have an air of mystery about him, so we're going to draw him floating in mid-air. Use a curve for the continuation of his body through to where his legs would end. Draw two large circles over his hands as a base for his magical orbs.

EVIL WIZARD

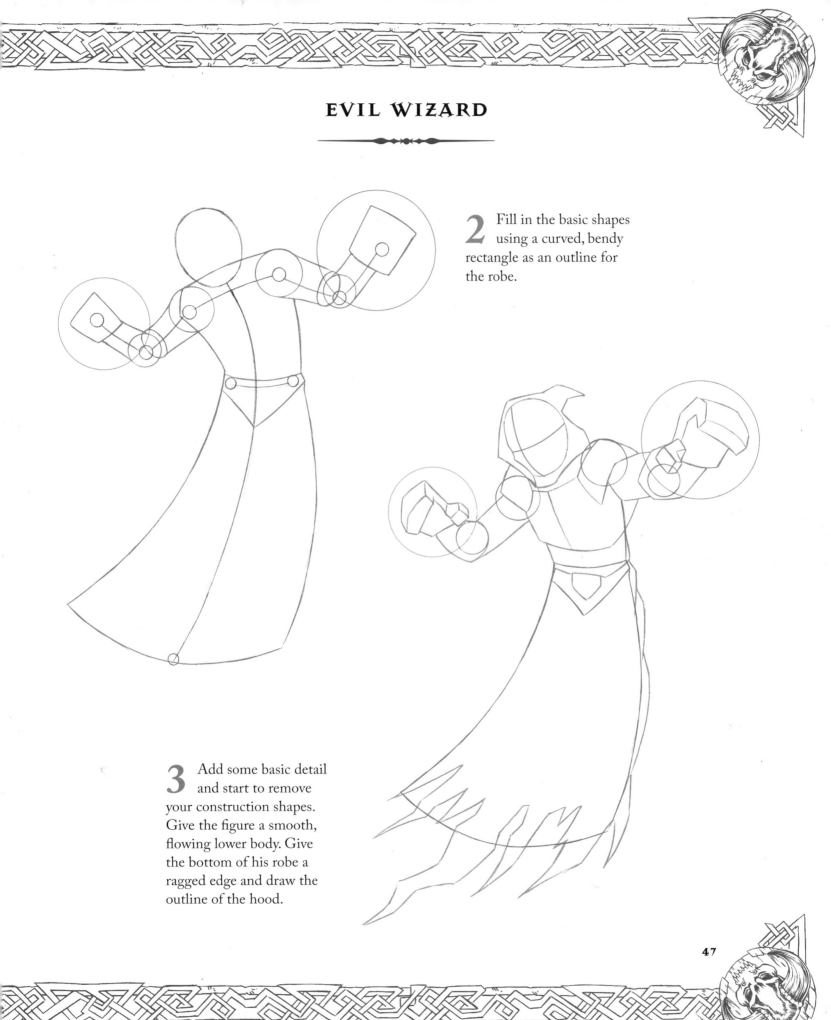

2 Fill in the basic shapes using a curved, bendy rectangle as an outline for the robe.

3 Add some basic detail and start to remove your construction shapes. Give the figure a smooth, flowing lower body. Give the bottom of his robe a ragged edge and draw the outline of the hood.

EVIL WIZARD

4 Once you're happy with your pencil outline, give your wizard wild eyebrows, a crooked beard and a wicked glare. Add the flowing detail at his waist and give his sleeves the same ragged outline as the bottom of his robe. Draw the curling fingers on his hands.

TOP TIP !

Use short, sharp lines to make the edge of the robe look all shaggy and ragged. Don't worry about joining up all the lines as the gaps will add to the effect.

EVIL WIZARD

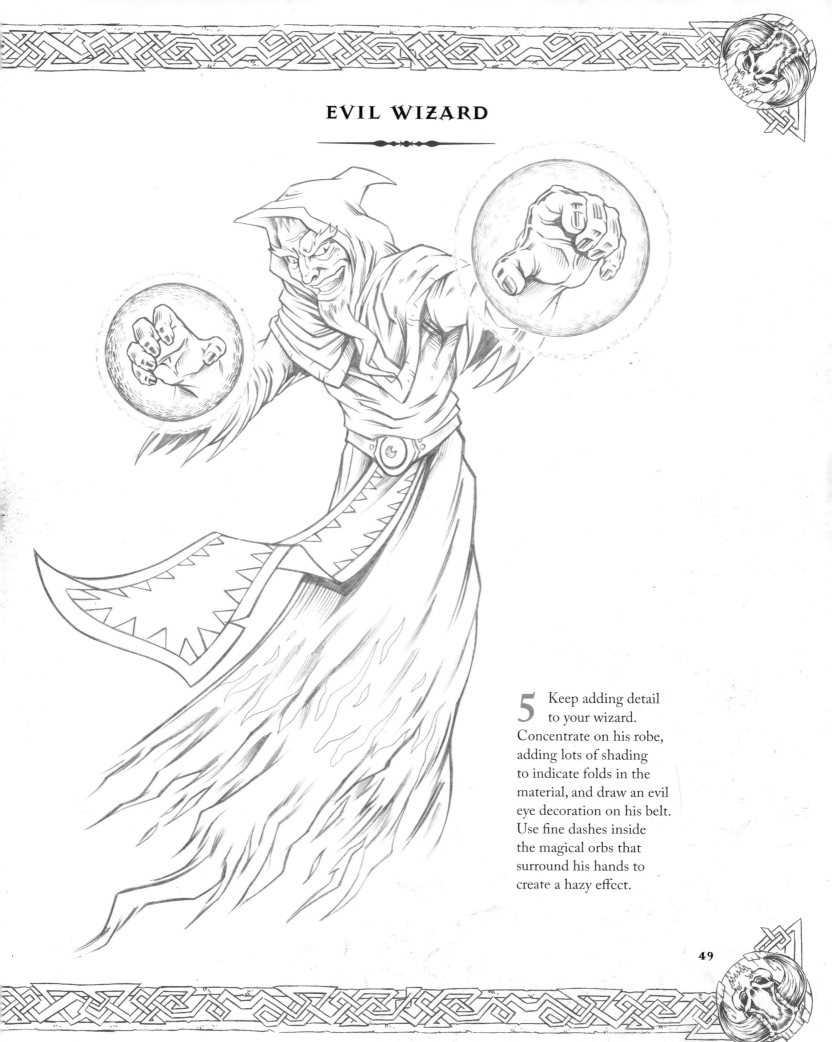

5 Keep adding detail to your wizard. Concentrate on his robe, adding lots of shading to indicate folds in the material, and draw an evil eye decoration on his belt. Use fine dashes inside the magical orbs that surround his hands to create a hazy effect.

EVIL WIZARD

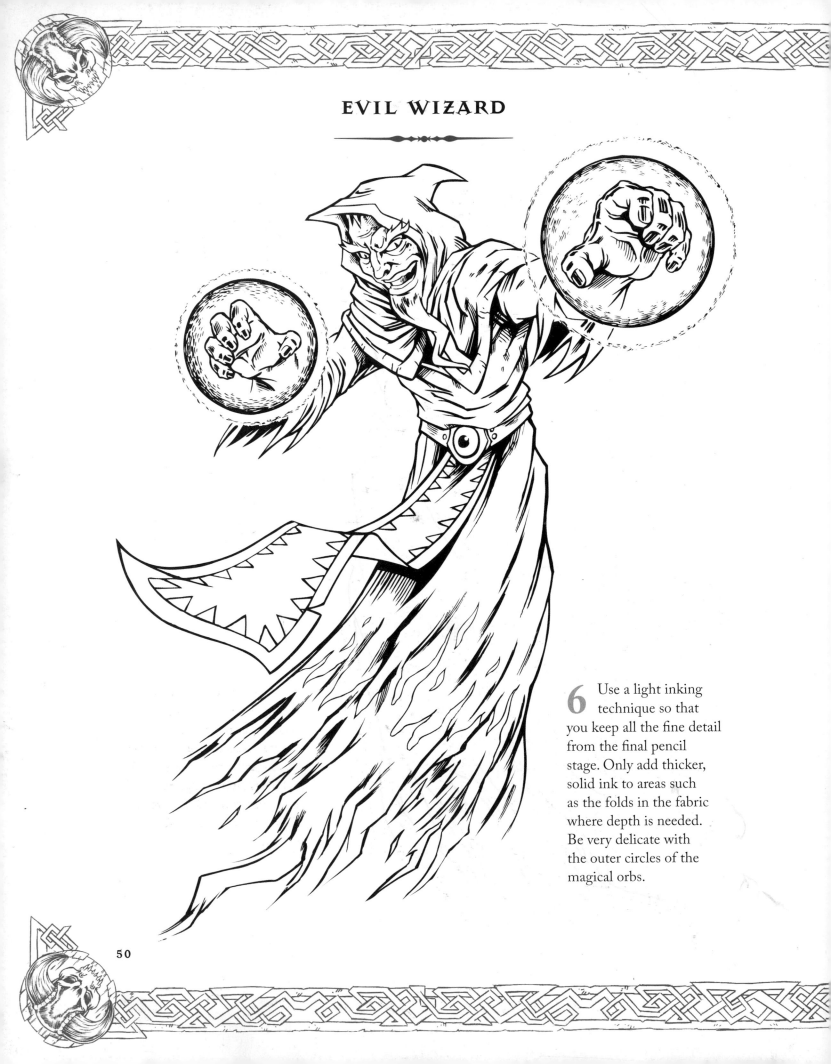

6 Use a light inking technique so that you keep all the fine detail from the final pencil stage. Only add thicker, solid ink to areas such as the folds in the fabric where depth is needed. Be very delicate with the outer circles of the magical orbs.

EVIL WIZARD

7 Dark blue robes will give your wizard a mysterious, malevolent quality. Use a bright green for his magical orbs to give them a glowing, unearthly feel. Note how some of the green glow has illuminated his face and robe.

The Good Army

Heroes' weapons are made with fair play in mind. They rely on the skill of the wielder to win the day, rather than foul play or sneaky attacks. Weapons created for good are made from wood, leather and pure metals.

CENTAUR'S SPEAR

A long and sturdy weapon. Ideal to use when charging at the enemy.

HAMMER

Most often used by dwarves. Made from stone chiselled from the depths of the mountains where they dwell.

WOODEN SHIELD

Adorned with a dragon's eye to give protection against evil during battle.

WARRIOR'S SWORD

A straight and trusty blade, often decorated with runes or jewels.

ELVEN BOW

Carved from the boughs of trees that grow in the enchanted forests where the elves make their home.

The Dark Army

These deadly weapons are designed to wreak havoc and destruction. They are used by wicked warriors, and are often enchanted with curses or dark magic to cause plagues and devastation with every blow.

SHAMAN'S STAFF

A fiery sceptre used to conjure up all manner of evil.

DEMON AXE

A mighty axe wielded by the wickedest warriors and charged with the blackest of magic for extra power.

ORC'S BLADE

A huge and deadly sword decorated with a spiked skull and made from cursed metals.

DEADLY DAGGER

A torturous weapon with sharp hand guards and a jagged blade for tearing flesh. It is also infused with a plague that will slowly poison and kill its victim.

EVIL SHIELD

Decorated with a malevolent face to strike fear in the heart of enemies.

ASSASSIN'S SICKLE

This is as deadly and sneaky as the warrior who wields it.

Magical Figures

These mysterious creatures dwell deep in the heart of enchanted forests where woodland magic is strongest. Often shy or solitary individuals, these magical beings avoid conflict with humans whenever possible. However, they are not to be underestimated; they are a formidable fighting force.

FOREST SPRITE

The forest sprites live among the moss and leaves of the woodland, barely visible to the untrained eye. They are not the biggest of creatures, yet they play a vital role in protecting the fairy queen's realm.

1 This little guy has long limbs and quirky features. Pay attention to the angular shape of your sprite's head when you start to plot your frame. Also draw the branch that he's perching on.

FOREST SPRITE

2 Build on your frame using basic shapes. Give the sprite large, bat-like ears and two small horns on the top of his head.

3 Sprites spend a lot of time in trees, so when you're fleshing him out, think about tree-dwelling creatures like monkeys, and the way that their limbs are formed. Start removing your construction shapes.

FOREST SPRITE

4 Once his body is in place, add the basic shape of two sets of wings. Give him a quirky, inquisitive expression and draw the magical ring he is holding. Large eyes and a small mouth will help to make him look otherworldly, as will his unusual hands and feet.

FOREST SPRITE

TOP TIP!

Studying trees where you live, or in photographs, will help you to recreate the branches and bark accurately.

5 Now add the final pencil details to your sprite. Give his furry patches some shading and draw the delicate veins on his wings and ears.

FOREST SPRITE

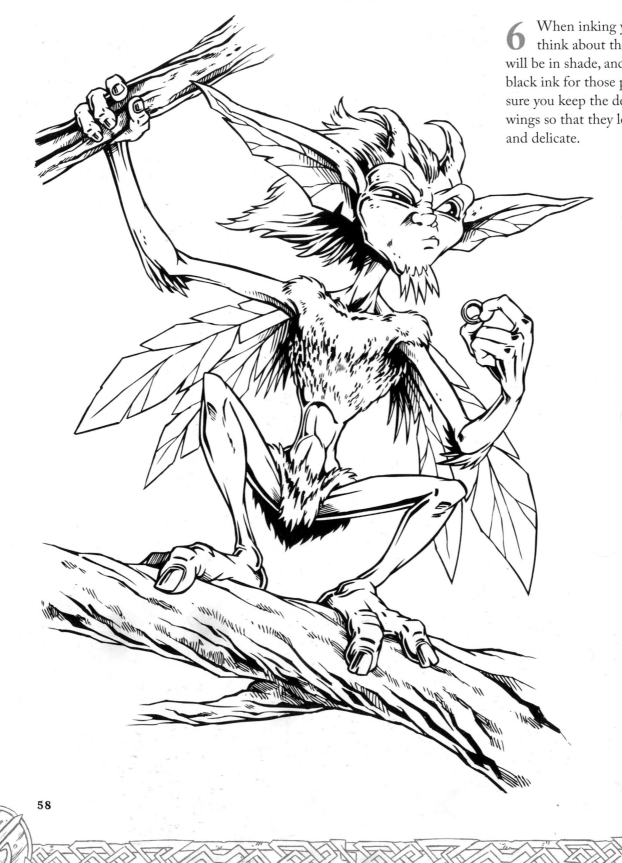

6 When inking your sprite, think about the areas that will be in shade, and use solid black ink for those parts. Make sure you keep the detail on the wings so that they look light and delicate.

FOREST SPRITE

7 As your sprite is a fantasy creature, you can really experiment with colour. Try giving him blue skin and use a mossy brown for his fur. Light, shimmery colours will work well for his wings, and bright yellow eyes will stand out against the blue.

CENTAUR

Half man, half beast, the centaur has the speed and power of a charging horse coupled with the weapon-wielding skills of a highly trained warrior. Loyalty, wisdom and power make the centaur an incredibly formidable opponent.

1 Start by drawing your wire frame. This figure is quite tricky, so take the time to draw the joints and limbs in the correct position. Getting the basic frame right will get you off to a good start.

2 Build on your frame using the basic shapes that we have used for the other characters. As horses have more joints than humans it might be useful to use a picture of one as reference to help you get the right proportions.

3 Erase all the basic shapes once you have set the outline of your figure. Mark in the main muscle sections on his chest. Add the outline of the his flowing hair and tail. Draw the outline of his spear.

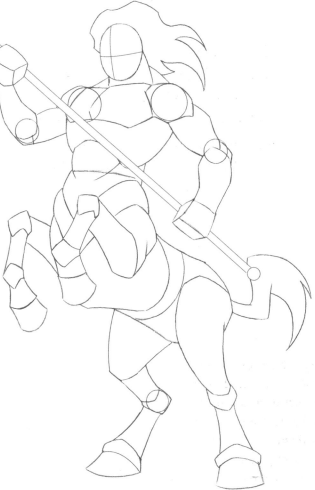

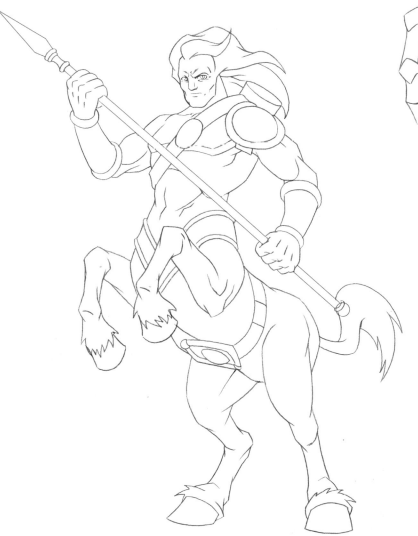

4 Start adding detail to your clean pencil drawing. Add his facial features, giving him a brave battle-ready expression. Draw in his armour and define his muscle tone. Add some tufts of fur to his hooves.

CENTAUR

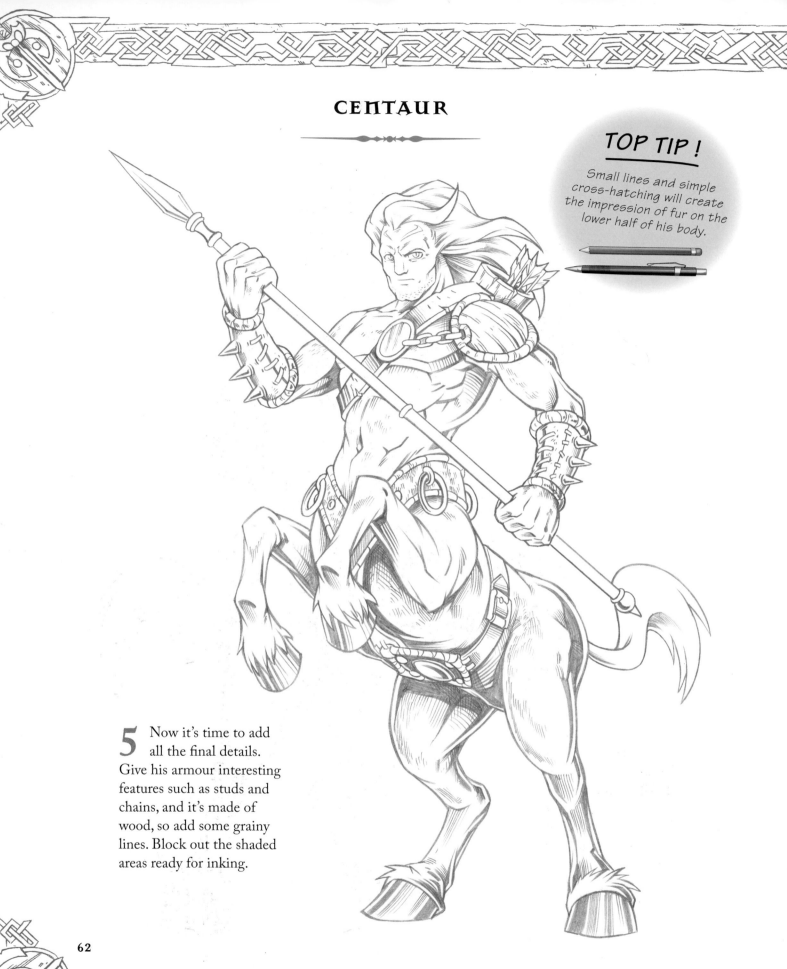

TOP TIP !

Small lines and simple cross-hatching will create the impression of fur on the lower half of his body.

5 Now it's time to add all the final details. Give his armour interesting features such as studs and chains, and it's made of wood, so add some grainy lines. Block out the shaded areas ready for inking.

CENTAUR

6 Time to add your ink. Using solid areas of black on his bottom half will create depth and define the individual limbs. Stripes of ink on the hooves will make them look shiny.

CENTAUR

7 The final step is to colour your centaur. Looking at different kinds of horses might inspire you to try some alternative colour schemes. Remember to match his hair colour and his tail colour.

ELF PRINCESS

She may appear fragile with youth, but the elf princess has lived longer and is much wiser than almost all the other characters. She is gifted with the powers of elven magic and control over the forces of nature.

1 Start by drawing your pencil frame, which should be tall and slim. The princess's right leg is positioned behind her left leg at the knee, as if she's taking a step towards us.

2 Now build on the frame with basic shapes, remembering to keep her looking young and feminine.

65

ELF PRINCESS

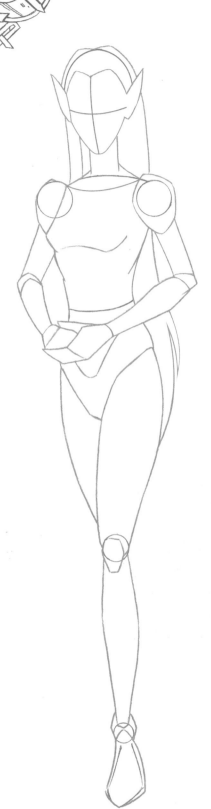

3 Once your figure has taken shape, remove your basic shapes and start cleaning up your pencil lines. Add the ears and hairline and the outline of her hair, which flows down her back.

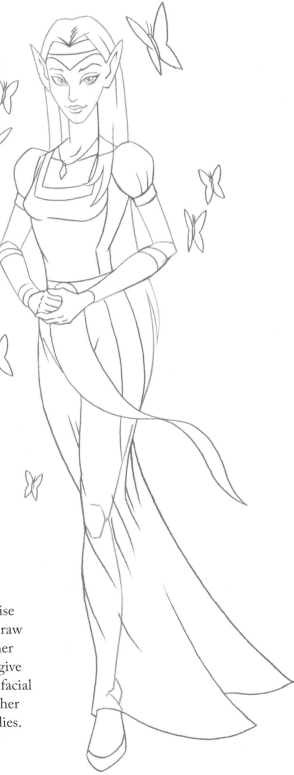

4 Begin to finalise your figure. Draw the fluid shape of her dress and belt and give her delicate, pretty facial features. Surround her with lots of butterflies.

ELF PRINCESS

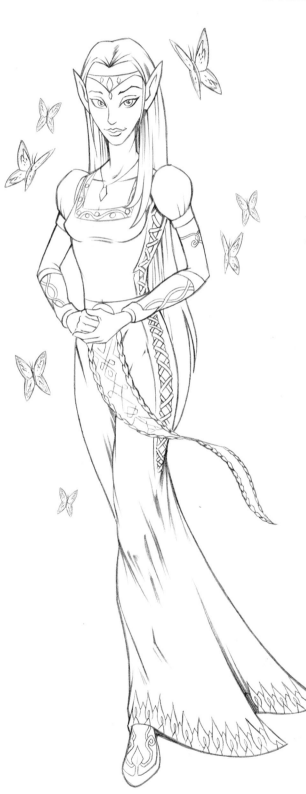

5 At the final pencil stage, add some embellishment to her dress and belt. Decorate her princess's headdress with precious stones. Mark in the light creases in her dress and the strands of her hair.

TOP TIP !

If your character is moving, it will affect the clothing he or she is wearing. Mark on lines to indicate the direction in which the fabric is moving.

ELF PRINCESS

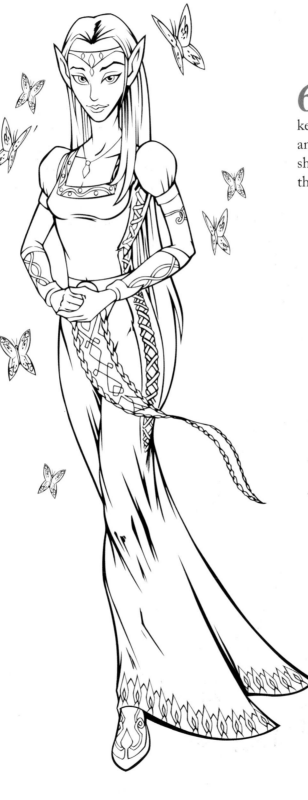

6 Now apply the ink making sure you keep your lines light and flowing. No heavy shading is needed for this delicate figure!

ELF PRINCESS

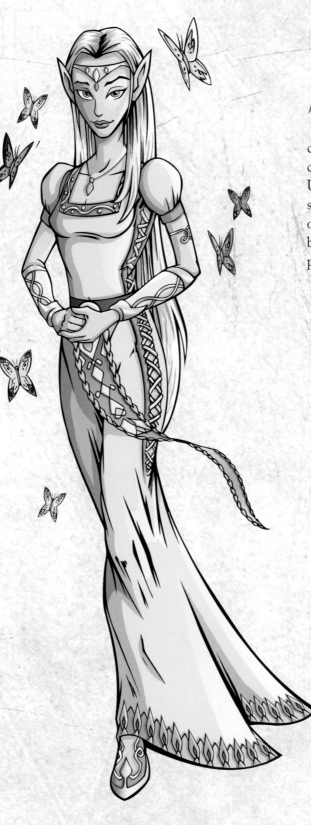

7 When colouring your elf princess, choose light, natural colours for her clothing. Use darker shades of the same colour to add areas of shading. Give her bright blonde hair and pale skin.

Drawing Different Expressions

Changing a character's facial expression can make them look completely different. You can create an infinite number of different facial expressions simply by changing your character's eyes, eyebrows and mouth.

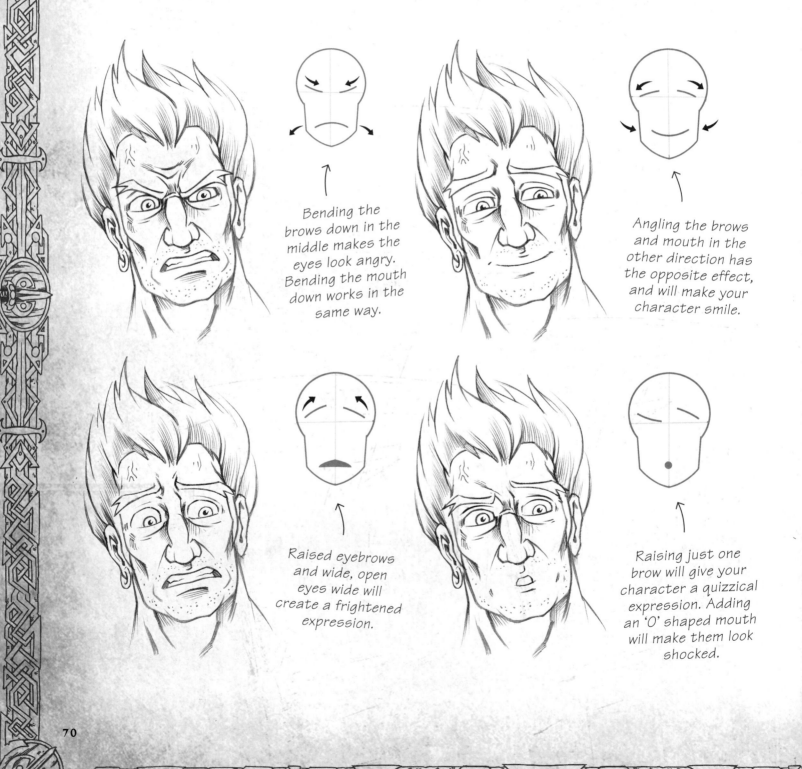

Bending the brows down in the middle makes the eyes look angry. Bending the mouth down works in the same way.

Angling the brows and mouth in the other direction has the opposite effect, and will make your character smile.

Raised eyebrows and wide, open eyes wide will create a frightened expression.

Raising just one brow will give your character a quizzical expression. Adding an 'O' shaped mouth will make them look shocked.

Expressions Gallery

Try some of these expressions with the many characters you create.

A knowing smile and focused eyes show cunning.

A furrowed brow and a yelling mouth will indicate rage.

Pursed lips and narrowed eyes will make your character look menacing.

Raised eyebrows and a gaping mouth will show shock or surprise.

TOP TIP !

Use these tips as a basis for your own experiments with expressions. If you get stuck, grab a mirror and start pulling different faces. It's a great way to learn how the face works. Just make sure you don't scare yourself!

Play around with expressions, but remember your character's personality. A happy face on a bad-tempered beast will just look wrong!

Beastly Beings

These warriors are mutant creatures, or animals that have been enchanted to take on human characteristics. They are usually created by evil leaders, who have no regard for the natural order of things. They are formidable fighters, and the unique magic they are endowed with protects them in strange and powerful ways.

RAT WARRIOR

From the shadowy rubble of ruined cities and long abandoned kingdoms, spew hordes of deadly rat warriors. Charging forth with wild eyes and ravenous jaws, they are ready to ambush and destroy any travellers who stray too close to their territory.

1 When drawing the rat warrior's frame, continue the basic spine line down, and loop back up to create the tail.

RAT WARRIOR

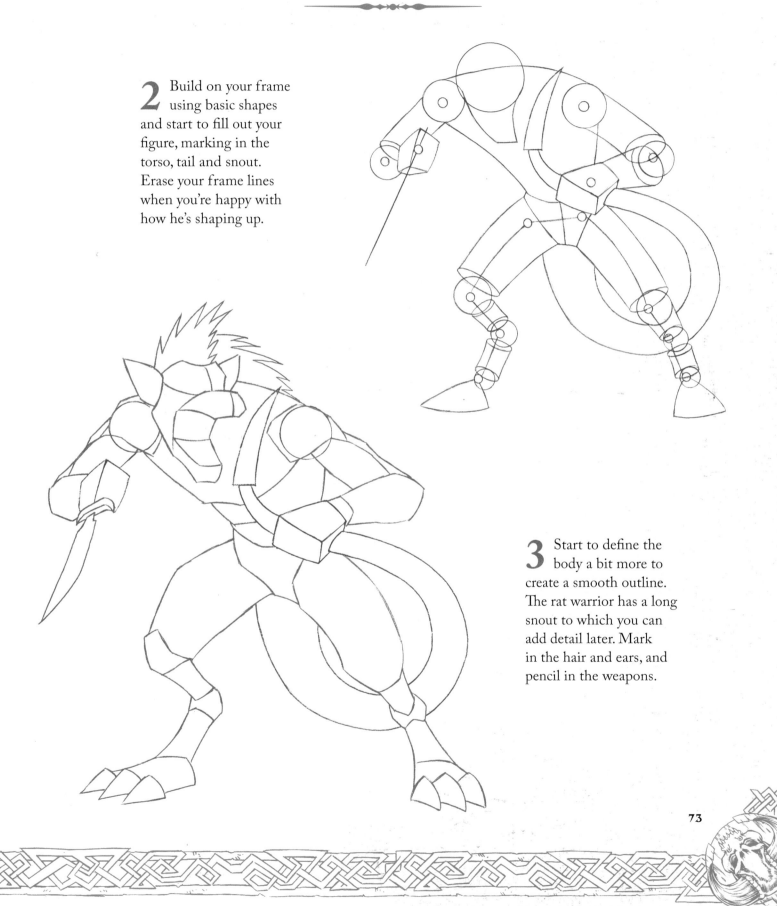

2 Build on your frame using basic shapes and start to fill out your figure, marking in the torso, tail and snout. Erase your frame lines when you're happy with how he's shaping up.

3 Start to define the body a bit more to create a smooth outline. The rat warrior has a long snout to which you can add detail later. Mark in the hair and ears, and pencil in the weapons.

RAT WARRIOR

4 Erase all of your basic shapes and lines, to leave a clean pencil drawing that's ready for detail. Draw his ragged clothing, tufts of fur, and his facial features including a set of razor-sharp teeth.

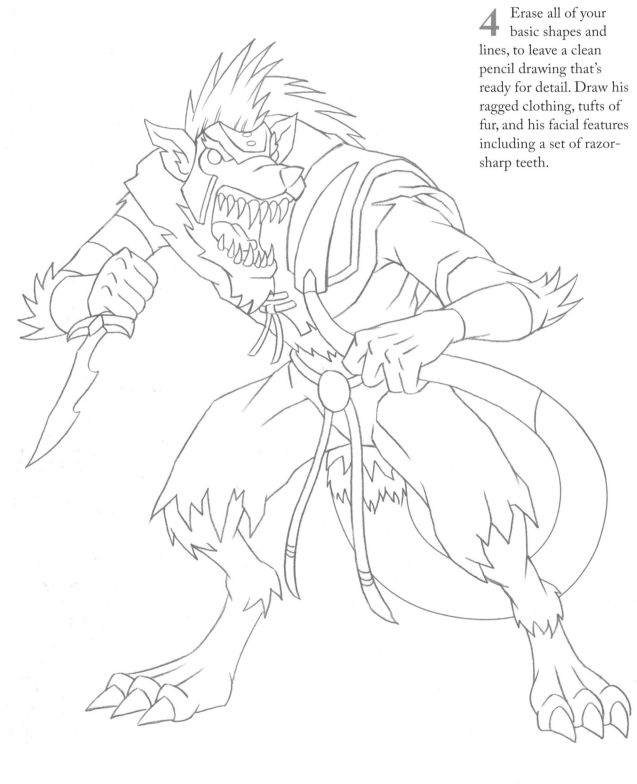

5 When adding the fine detail, develop his tattered clothing by adding in lots of rips and tears. Leave his eyes pupil-free to give him an unearthly look. Add texture to the fur and start shading.

TOP TIP !

Try experimenting with the balance of animal and human characteristics. The rat warrior's stance and body shape are his human qualities.

75

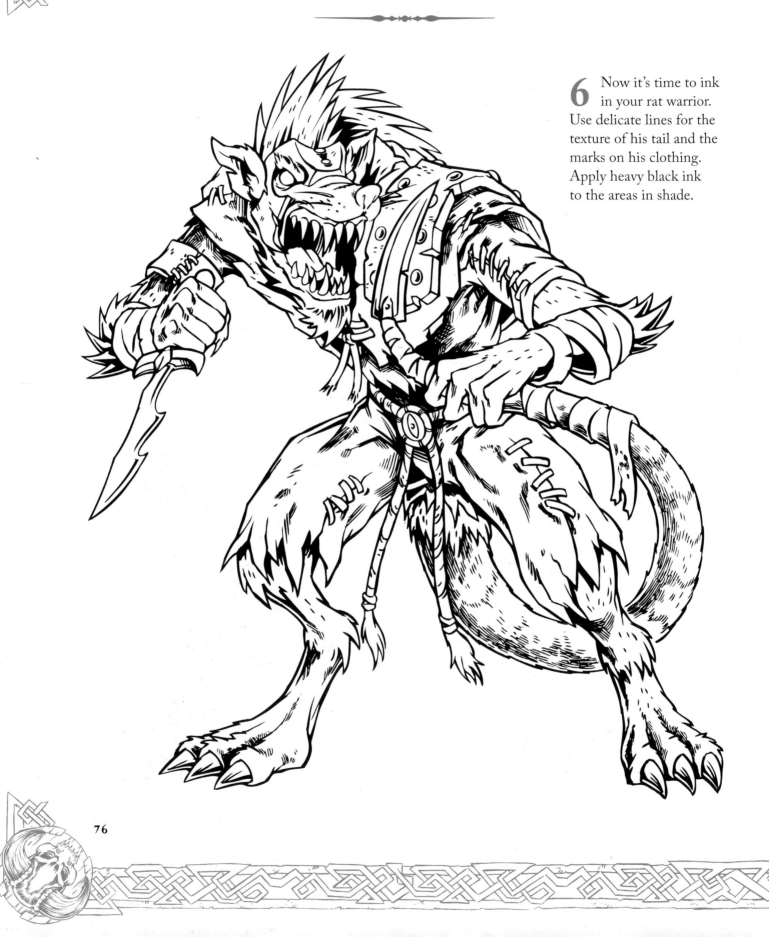

6 Now it's time to ink in your rat warrior. Use delicate lines for the texture of his tail and the marks on his clothing. Apply heavy black ink to the areas in shade.

RAT WARRIOR

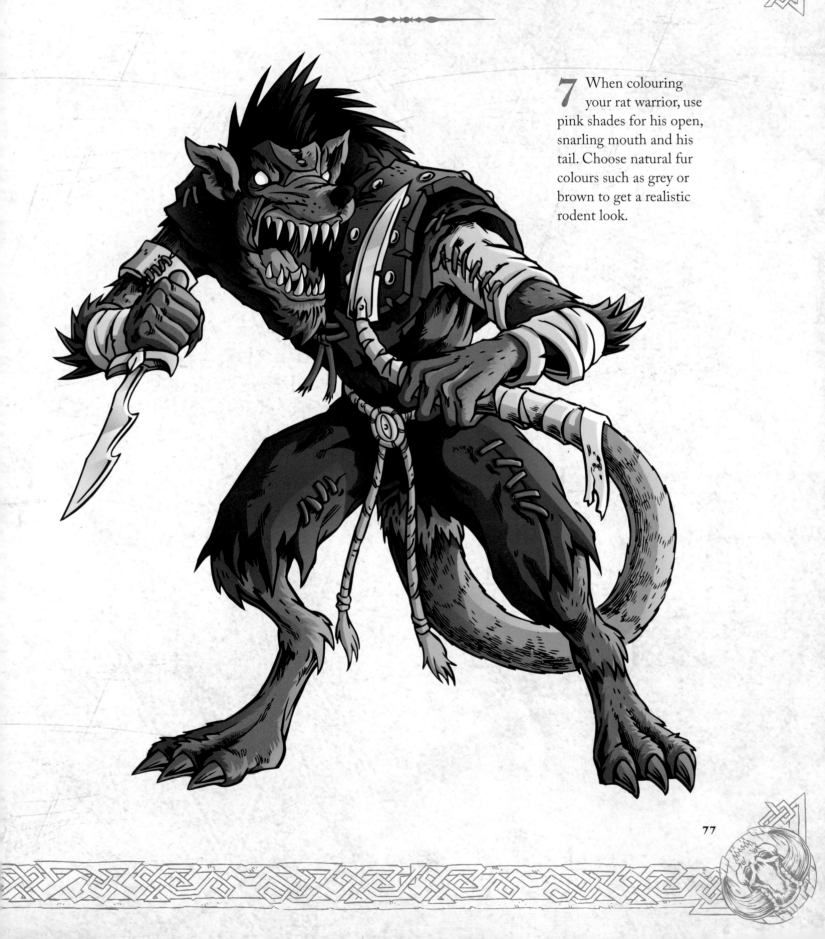

7 When colouring your rat warrior, use pink shades for his open, snarling mouth and his tail. Choose natural fur colours such as grey or brown to get a realistic rodent look.

EAGLE GUARD

These formidable winged beasts once lived a
solitary existence high up on the mountain
peaks. However, under the demon lord's
instruction, these creatures have begun
to wander into the land of light in search
of bigger prey and the spoils of war.

1 Start by drawing your
wire frame. Plot all the
joints, and draw a line for
his staff. The eagle warrior is
flying, so draw the wing lines
above his body in the air.

2 Fill out the body and
wings with basic shapes.
His head is ducking forwards
and down, as he is flying ahead.

EAGLE GUARD

3 As your figure takes form, remove your working lines and basic shapes. Sketch in the head, beak, wings and claws. Draw the outline of the blade at the end of his staff.

4 Now add detail to your clean pencil drawing. Draw ziagzag shapes for the feathers along the outside of the wings. Add his beady eagle eyes, feathery eyebrows and headdress. Define the shape of his blade, add muscle tone to his body, and give him some razor-sharp claws.

EAGLE GUARD

5 Finalise your pencil drawing. To finish the wings, draw layers of feathers that start off small at the base of the back, and get larger towards the tip of the wing. Use fine lines to add a feathery effect to the body, arms and legs. Block in your shaded areas for solid inking.

TOP TIP !

To create the effect of a mass of feathers, draw groups of about four or five zigzag feather shapes, and then overlap them to create layers.

6 Inking all the detail in this character is a tricky task, so take your time. Don't worry if you lose some of the very fine pencil lines, just try to keep as much detail as you can. Areas of solid black add depth, and will help to put the drawing in perspective.

EAGLE GUARD

7 When colouring your character, think about the natural colouring of eagles and their markings. Brown and white feathers, and yellow feet and beak will make your eagle warrior look authentic.

LIZARD MAN

From the swamps that lie beyond the land of light, come the lizard men. Armour-clad, with lethally quick reactions, they are a fearsome addition to the dark lord's army. Any opponent within tail's reach is in deadly danger.

1 Start with your basic frame. The best place to start the lizard man's tail is at the base of the spine, where it joins the hip line.

2 Build the lizard man using your basic shapes. This character is drawn from a side-on perspective.

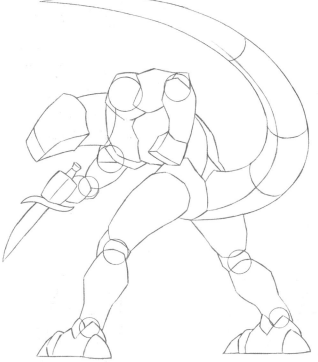

3 Now flesh out your figure and remove your construction shapes as you finalise your lines. Note the shape of the reptilian head and feet, which are longer and more angular than a human's.

4 Once you have a clean pencil drawing, start adding detail. Begin to draw the reptilian scales, and add some pointed spines running down the length of his back and tail. Mark in his tongue, facial features, weapon and clothing.

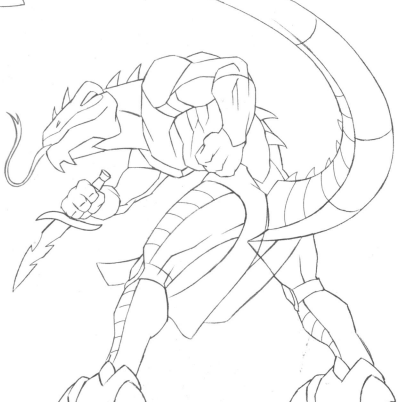

LIZARD MAN

TOP TIP!

Reptilian scales are shiny. Drawing a smooth, dark shadow down one side will create their polished surface.

5 Detailed shading is key to the final pencil stage. It will define each scale and create a light effect to make the surface look shiny.

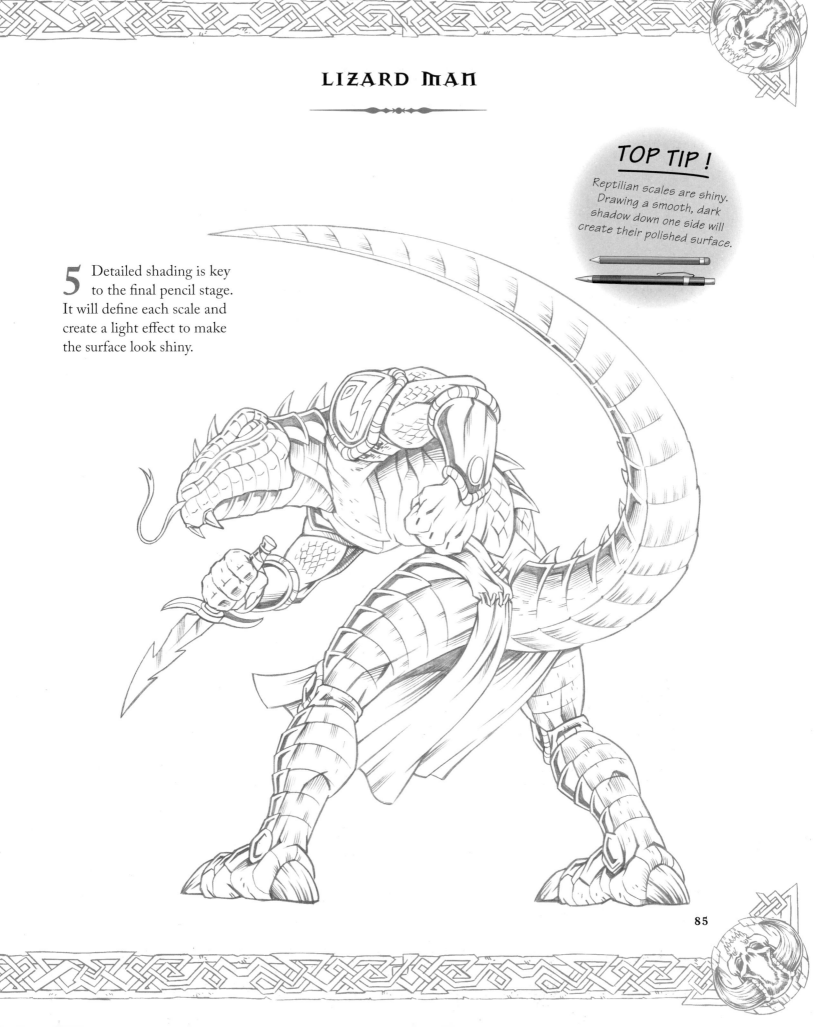

LIZARD MAN

6 When inking your lizard man, use different line thicknesses for different areas on his body. The scales on his face and upper arms require a fine inking technique, whereas a heavier stroke is needed for his armoured legs and tail.

LIZARD MAN

7 Now it's time to colour your character. Look at pictures of lizards in the wild. Greens, browns and yellows will help you to create a classic reptilian look.

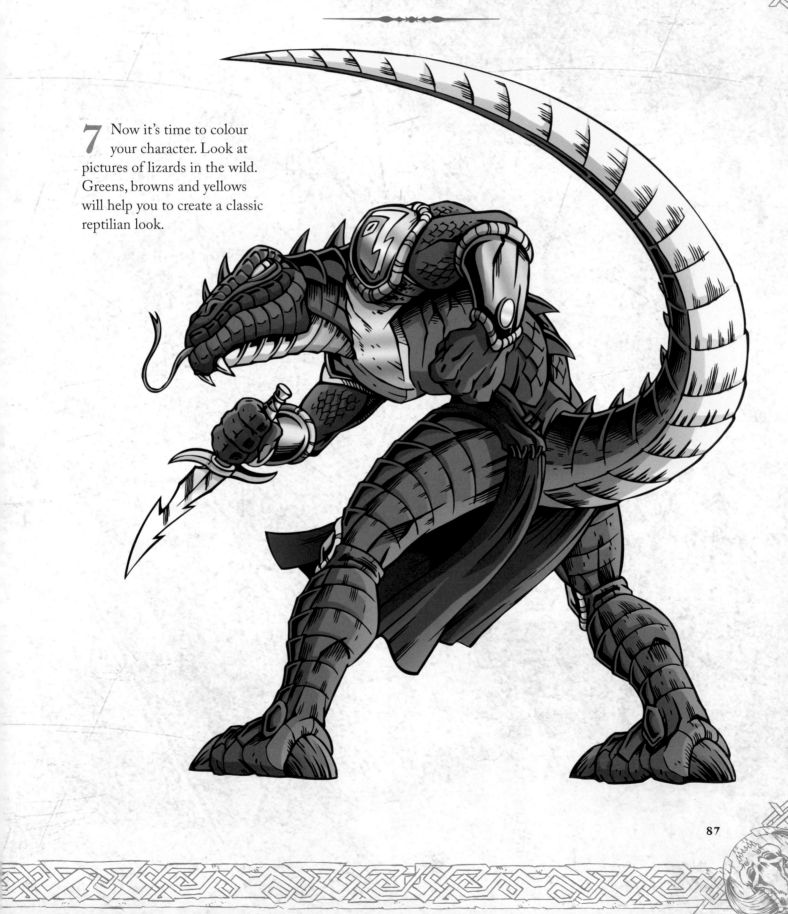

Fur and Claws

When you're drawing a figure with animal characteristics, there's a good chance you'll have to create the impression of fur, and draw some sharp claws. Here are some clever tricks to help you get great results.

FUR

Hairy beasts have thousands of individual hairs on their bodies. Obviously it would take far too long to draw every single one, so copy the techniques below to create the impression of a furry covering.

TOP TIP !

Use short pencil strokes to draw clumps of fur, and then layer the clumps to cover your beast's body.

CLAWS AND HORNS

Careful shading in pencil and ink will make your claws and horns look three-dimensional. Think about where the light would be hitting them and add highlights.

Scales and Feathers

The secret to scales and feathers is to make a little detail look like a lot. By repeating uniform shapes to create closely-packed layers of detail, you'll create the impression of lots of individually drawn pieces.

SCALES AND TAILS

Scales are shiny, hard and reflective. Make sure your creature's limbs are segmented and neat, and then add shadow to one side to show where the light is falling.

TOP TIP !

Draw feathers in blocks of four or five and then overlap them.

FEATHERS

Feathers, like fur, would take forever if you were to try to draw every single one in detail. Instead, draw a basic almond shape, then repeat and overlap to make a simple pattern that has the same effect as lots and lots of feathers!

Mighty Leaders

These mighty leaders need to be strong and ruthless, as well as fair and kind. To retain rulership over the land of light, they often have to unite the good army to defend their kingdoms from evil forces. They each have unsurpassable powers, skills and magical talents, and when they join forces, even the most wicked of rulers cannot overthrow them.

KING

The King stands mighty and defiant against all oncoming darkness – a leader for all who fight on the side of good. Wise, kind and true, he leads his people into battle, his presence instilling a sense of power into those who fight alongside him.

1 Start with a strong and sturdy pose for our all-powerful ruler. His legs should be straight and planted firmly on the ground.

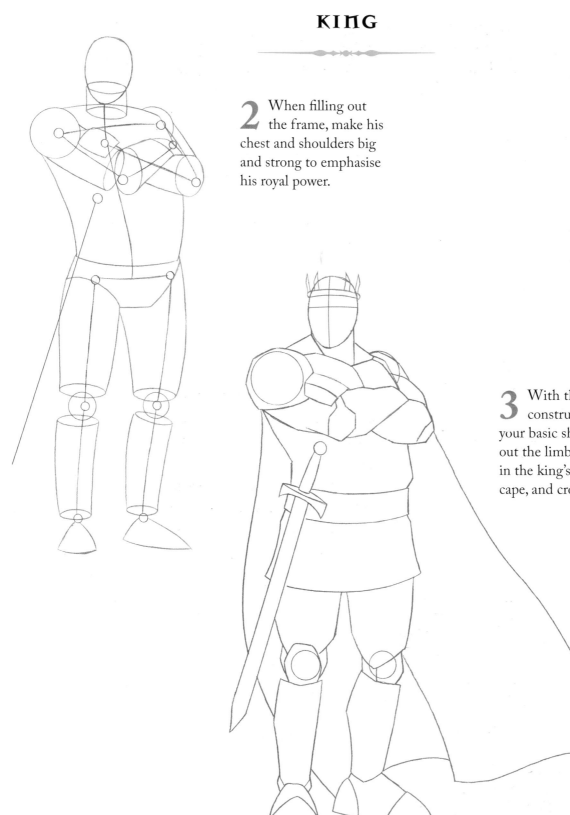

2 When filling out the frame, make his chest and shoulders big and strong to emphasise his royal power.

3 With the basic body constructed, remove your basic shapes. Flesh out the limbs and mark in the king's tunic, sword, cape, and crown.

KING

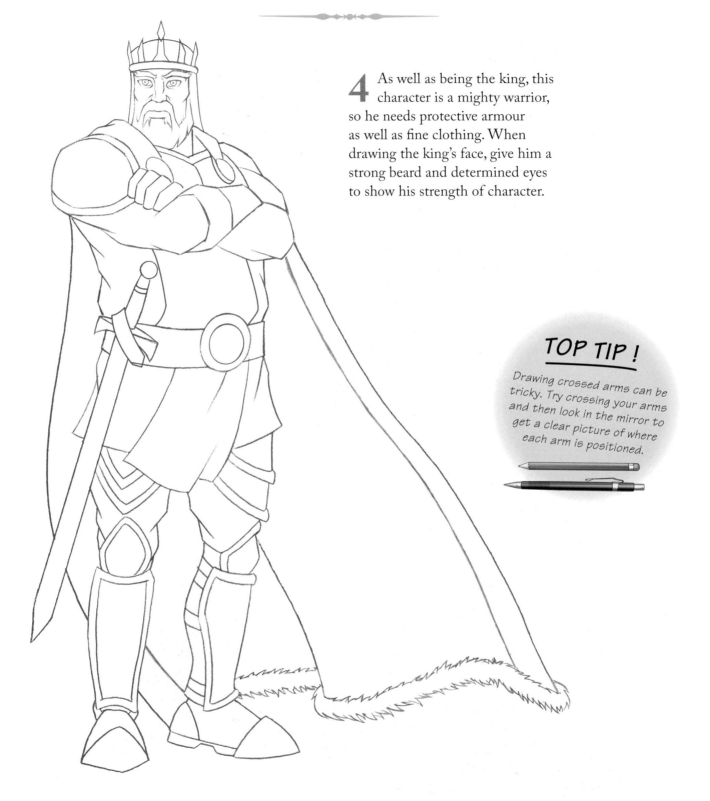

4 As well as being the king, this character is a mighty warrior, so he needs protective armour as well as fine clothing. When drawing the king's face, give him a strong beard and determined eyes to show his strength of character.

TOP TIP !

Drawing crossed arms can be tricky. Try crossing your arms and then look in the mirror to get a clear picture of where each arm is positioned.

KING

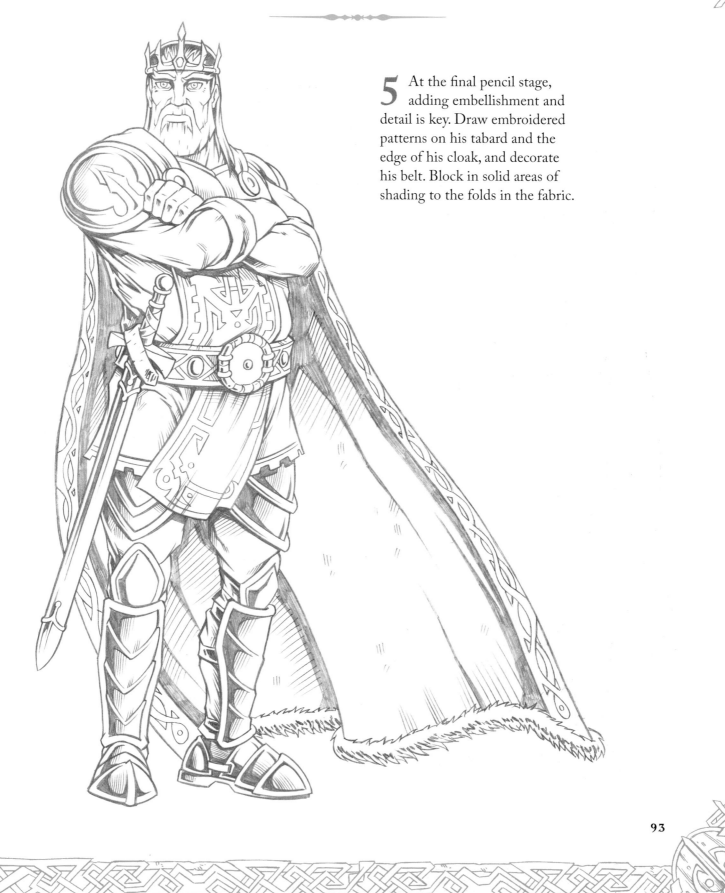

5 At the final pencil stage, adding embellishment and detail is key. Draw embroidered patterns on his tabard and the edge of his cloak, and decorate his belt. Block in solid areas of shading to the folds in the fabric.

KING

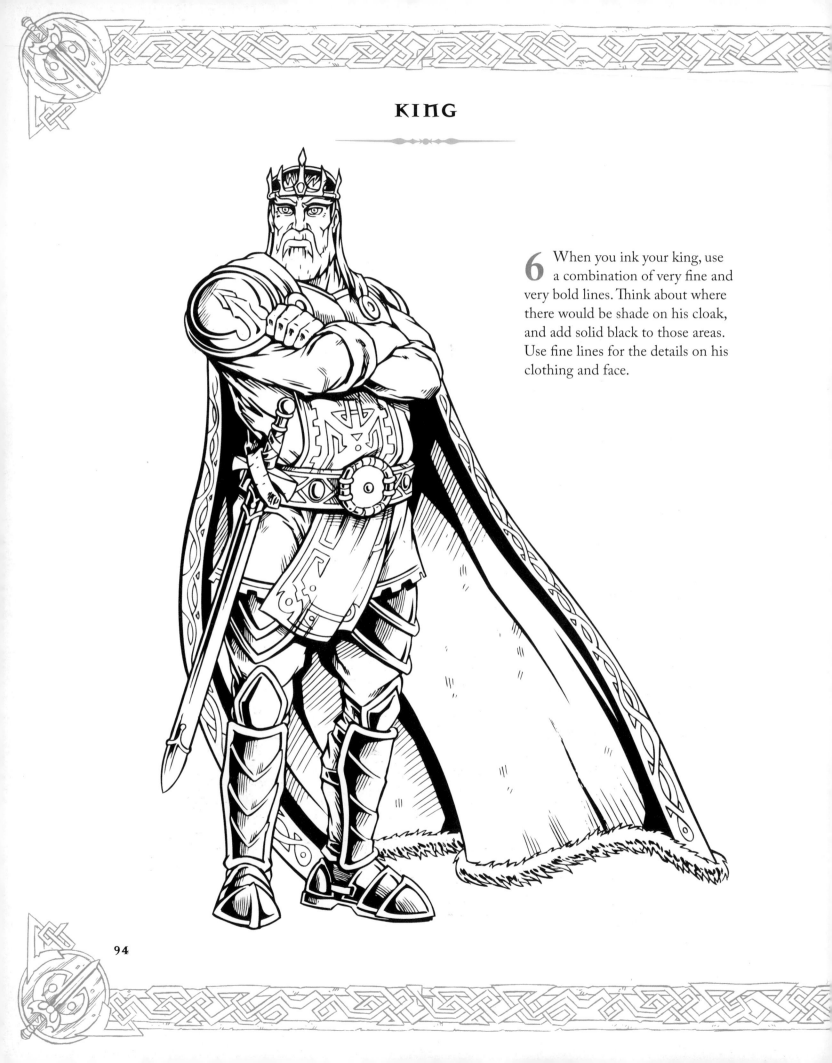

6 When you ink your king, use a combination of very fine and very bold lines. Think about where there would be shade on his cloak, and add solid black to those areas. Use fine lines for the details on his clothing and face.

KING

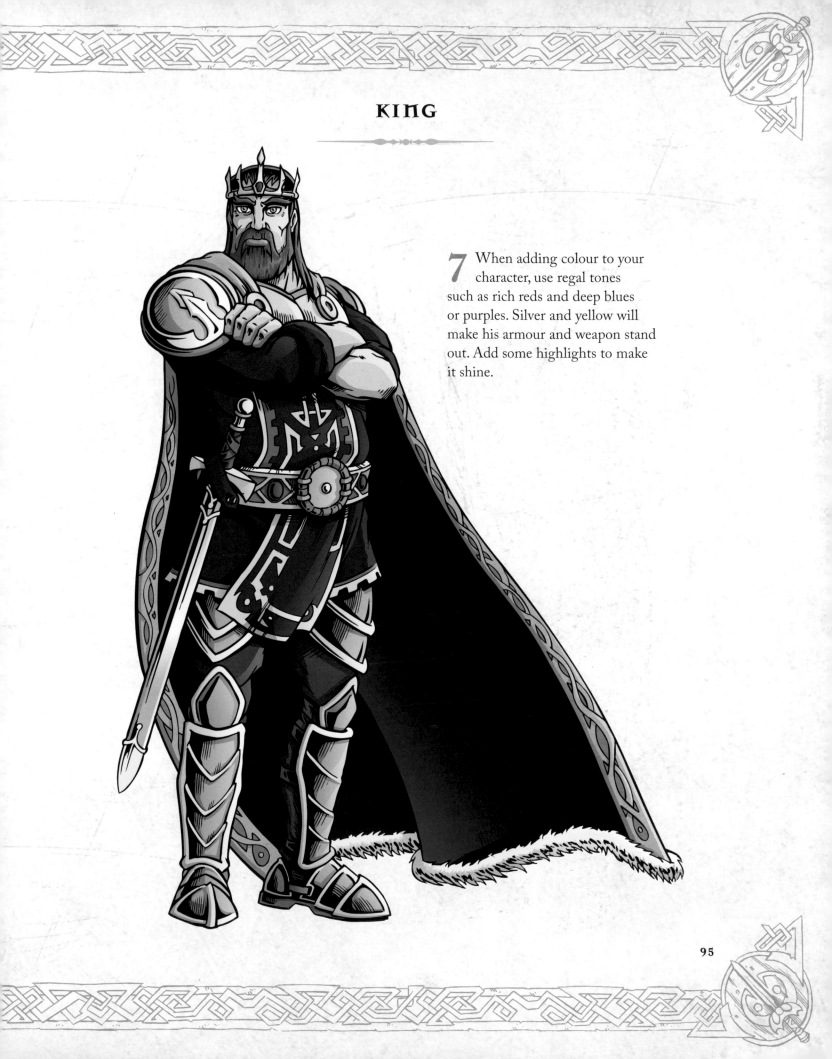

7 When adding colour to your character, use regal tones such as rich reds and deep blues or purples. Silver and yellow will make his armour and weapon stand out. Add some highlights to make it shine.

FAIRY QUEEN

As ethereal and beautiful as the land of
light itself, the fairy queen leads her people
against the forces of darkness. She wields
the mightiest of all powers – the power
to control the natural elements. She can
conjur a storm in seconds, and has fire at
her fingertips.

1 Start by drawing
the wire frame.
Give your fairy queen a
light, graceful posture.
As she will be flying, her
feet need to be pointing
towards the floor, rather
than resting flat on it.

2 Build on your frame
with basic shapes,
keeping the flow and
curve of her feminine
form. Start the basic
framework for two tiny
fairies that are holding
her silken belt.

FAIRY QUEEN

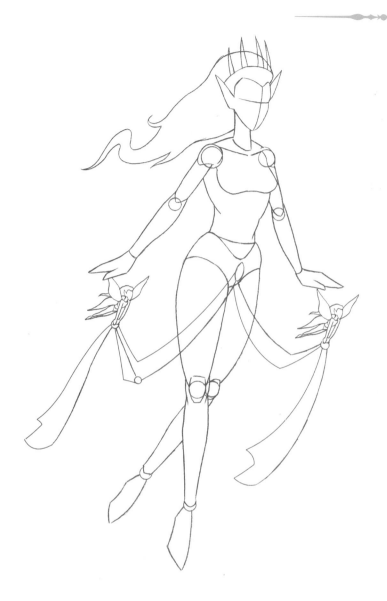

3 Remove your wire frame and pencil in the outline of her body, hair and crown. Develop the shape of the smaller fairies and the scarf they are holding.

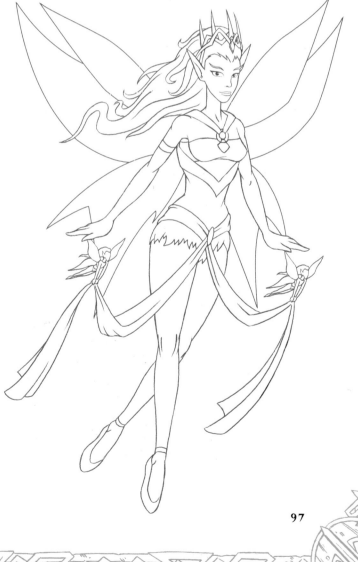

4 Once you have a clean outline and have erased your basic shapes, pencil in her wings, the strands in her hair, and her clothing. Draw her facial features, giving her an open peaceful expression.

FAIRY QUEEN

TOP TIP !

Layer the leaves in her skirt as you would with feathers. This will create a dense look and will save you from having to draw each individual leaf.

5 Now add all your finishing touches. Draw in the different segments on her wings and the vines that wind around her legs and through her hair. Decorate her crown and jewellery and draw her leafy skirt. Add shading and detail to the two smaller fairies.

FAIRY QUEEN

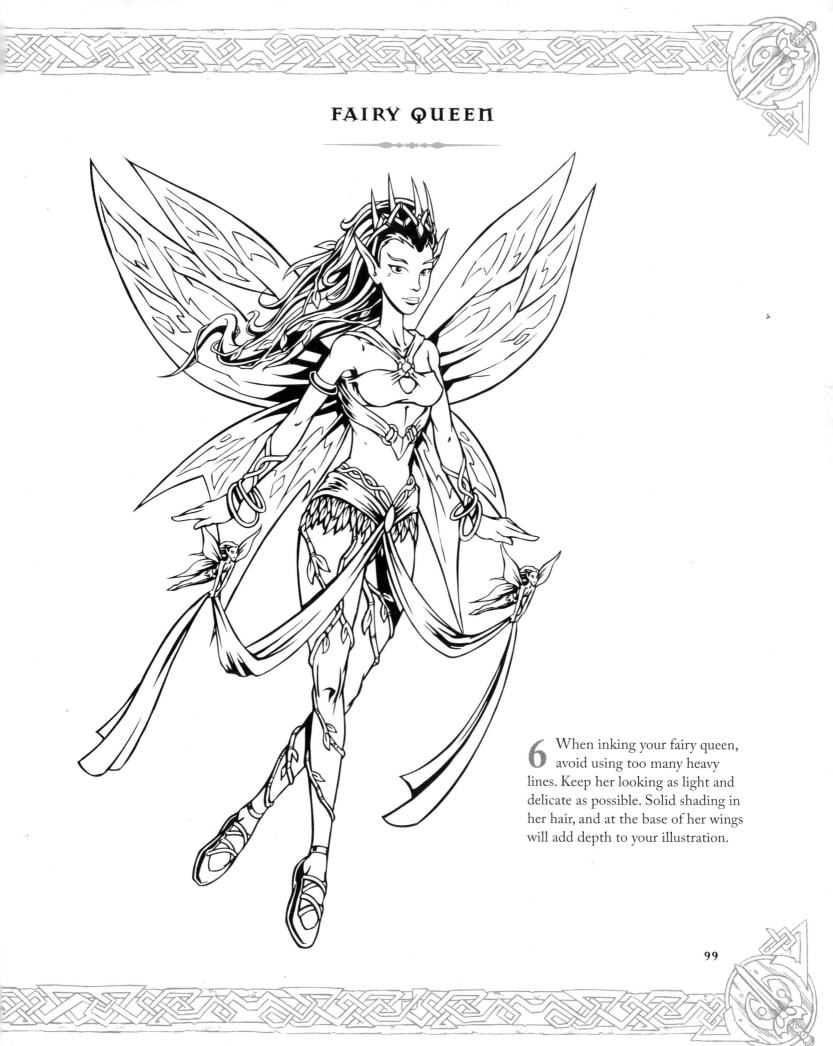

6 When inking your fairy queen, avoid using too many heavy lines. Keep her looking as light and delicate as possible. Solid shading in her hair, and at the base of her wings will add depth to your illustration.

FAIRY QUEEN

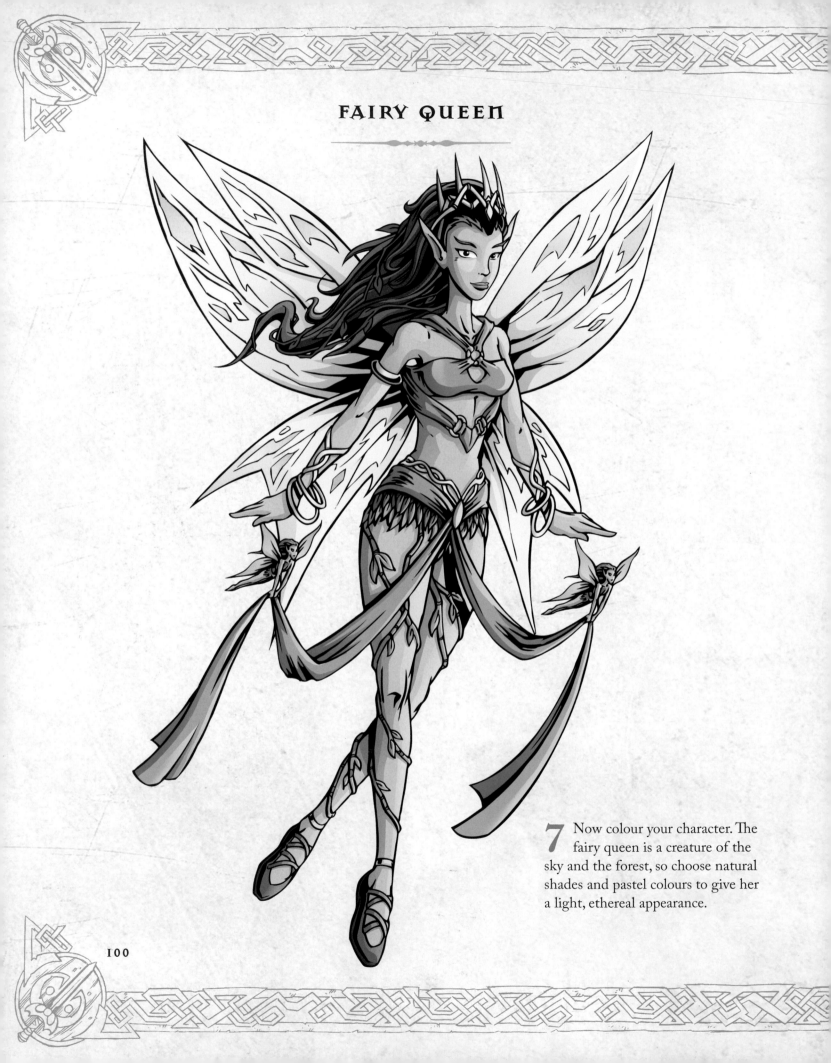

7 Now colour your character. The fairy queen is a creature of the sky and the forest, so choose natural shades and pastel colours to give her a light, ethereal appearance.

ELF PRINCE

Though not as physically strong and imposing as a warrior or an orc, this regal and revered fighter is just as dangerous. He relies on his deadly accurate aim, naturally heightened senses, and athletic skills to see him through a battle.

1 Start by drawing your frame, adding the bow he is pulling back, ready to fire.

2 Build on your frame using basic shapes. His left arm, that's stretched out in front, will appear larger as it's further forward.

ELF PRINCE

3 Fill out the body, and erase your construction shapes. Draw his elf ears, weapon and clothing as your prepare your clean pencil drawing.

4 Once you're happy with your outline, add detail. Draw in all of his armour, his crowned helmet, belt and cloak. Give him refined facial features. Almond eyes, and a small nose and mouth will create the elf look.

ELF PRINCE

5 Add lots of shading to your final pencil drawing. The solid shaded areas will look very dramatic once they're inked in. Keep his outfit simple, but add decoration to his belt buckle and crown.

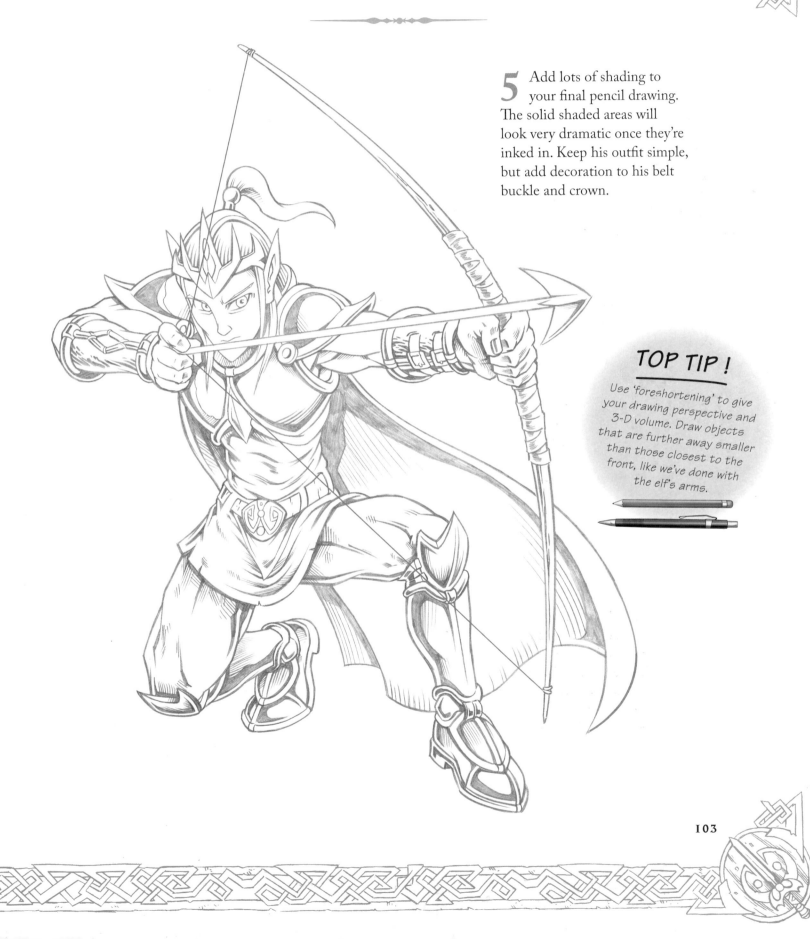

TOP TIP !

Use 'foreshortening' to give your drawing perspective and 3-D volume. Draw objects that are further away smaller than those closest to the front, like we've done with the elf's arms.

ELF PRINCE

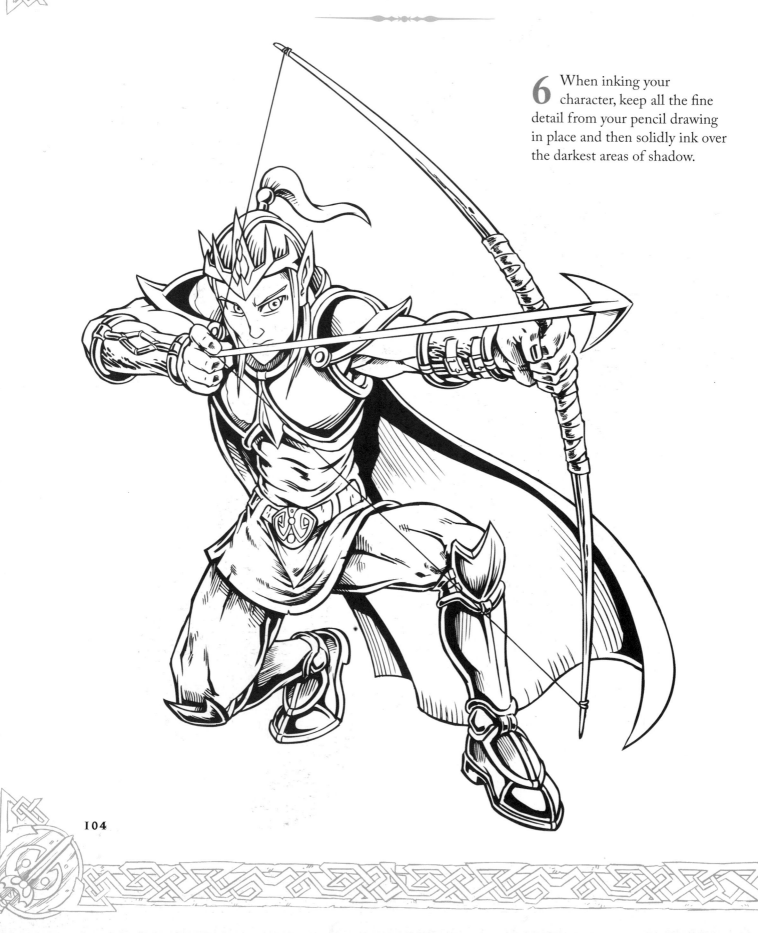

6 When inking your character, keep all the fine detail from your pencil drawing in place and then solidly ink over the darkest areas of shadow.

ELF PRINCE

7 Finally, add colour to your character. Shiny silver armour will give him a battle-ready look, and a dark green cloak will help him to camouflage.

TIPS : THE IMPORTANCE OF DETAIL

Light and Shade

Shading gives your drawings depth and stops them from looking flat on the page. Before you add shading or highlights think about the different materials you have drawn. Some will absorb the light, whereas others reflect it.

ADDING DEPTH

Look at the two images of this goblin arm (right). When shading is added, the sleeve of the goblin's cloak suddenly looks hollow, and the beads on his arm are given a spherical, 3-D appearance.

LIGHT SOURCE

Here we can see how the light source is casting a shadow on the drawing, and also how the goblin's beads catch the light. Use white or paler versions of your colours to add highlights.

METAL OBJECTS

This shoulder guard is made of metal, which reflects the light. To create this effect, draw a strong shadow on the side that's furthest away from the light source.

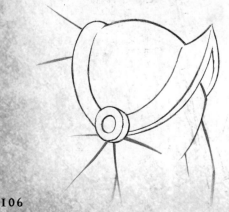

TOP TIP !

Remember to keep your light source consistent. If the light source is coming from one direction, make sure your shadows fall on the opposite side to the light.

Adding Finishing Touches

Adding final details to a character's clothing, face and body really brings them to life. They can reveal clues to your character's age, feelings and status. Try looking at historical clothing and theatrical costumes for inspiration.

CLOTHING

1 On the left is a very simple top that a female character might wear. To make it look more interesting, we need to add some decoration.

2 Embroidered patterns around the neckline and on the sleeves add interest, and criss-cross lacing is a popular period detail.

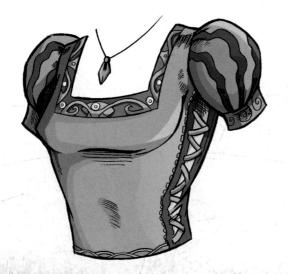

3 When you colour your character think about their personality and status. Use nature as your inspiration for elves and fairies, rich purples and blues give a regal impression, and old, brown clothes suggest poverty.

ACCESSORIES

Accessories such as belts, helmets and leather arm guards always look a bit more fantastical when decorated with runes or jewels. Various holes, cuts and scratches will make your armour look battle-worn.

Wicked Rulers

Not all kings and queens are kind, and authority can often corrupt those who wield it. That certainly seems to be the case with this wicked set of characters. These power-hungry monarchs are always seeking control of rival kingdoms, and woe-betide anyone, or anything, that stands in their way.

ICE QUEEN

Striding forth from her frozen citadel, as cold as the ice itself, this frosty female steps into battle. She draws on dark magic to transform the ice she walks upon into razor-sharp shards, that become her protective icy armour.

1 Start by drawing your wire frame. Give the ice queen a strong stance. Note the curve of the spine and the hand on her hip. Also draw the frame for her arctic ally and the line for her staff.

ICE QUEEN

2 Build on your frame with basic shapes. Construct the curling ice formations at the bottom of her dress, and the layers of her cloak. Draw a circle at the top of her magical staff, and pencil in the shape of her arctic fox.

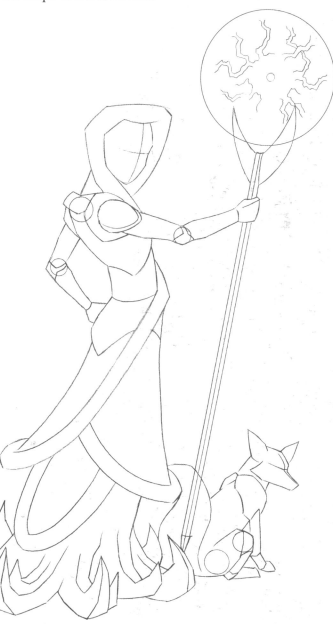

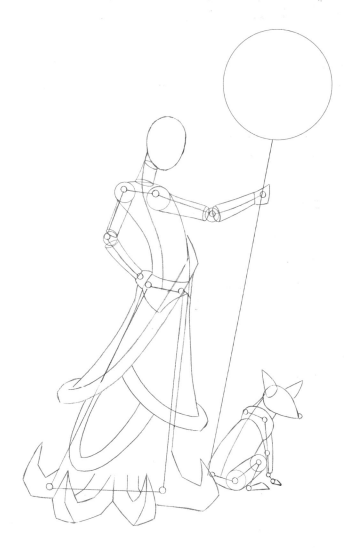

3 Erase your framework and start to shape the structure of her robe. Continue the trim on her cloak up and around her head for the hood. Add some more icy chunks to the bottom of her dress and mark in the electricity inside her magical staff.

ICE QUEEN

4 We need the ice queen's cold and cruel nature to be reflected in her clothing and expression. Frame her face with a spiky crown and add some icy armour to her arms and shoulders. Give her a stern stare and a malicious mouth. Draw the fur trim on her cloak, and finalise her arctic fox.

5 At the final pencil stage use sharp, jagged lines for her icy armour. Apply soft strokes for the fur on her cloak, and her fox's coat. Add shading to the bottom of her dress to give the curling ice a 3-D appearance. Use smudgy shading and thin lines to shape her crackling, electric power ball.

TOP TIP !

Small animals and fantasy creatures are fun to show alongside your figures. Try inventing companions for the other characters - think about the kind of sidekick the orc might have!

ICE QUEEN

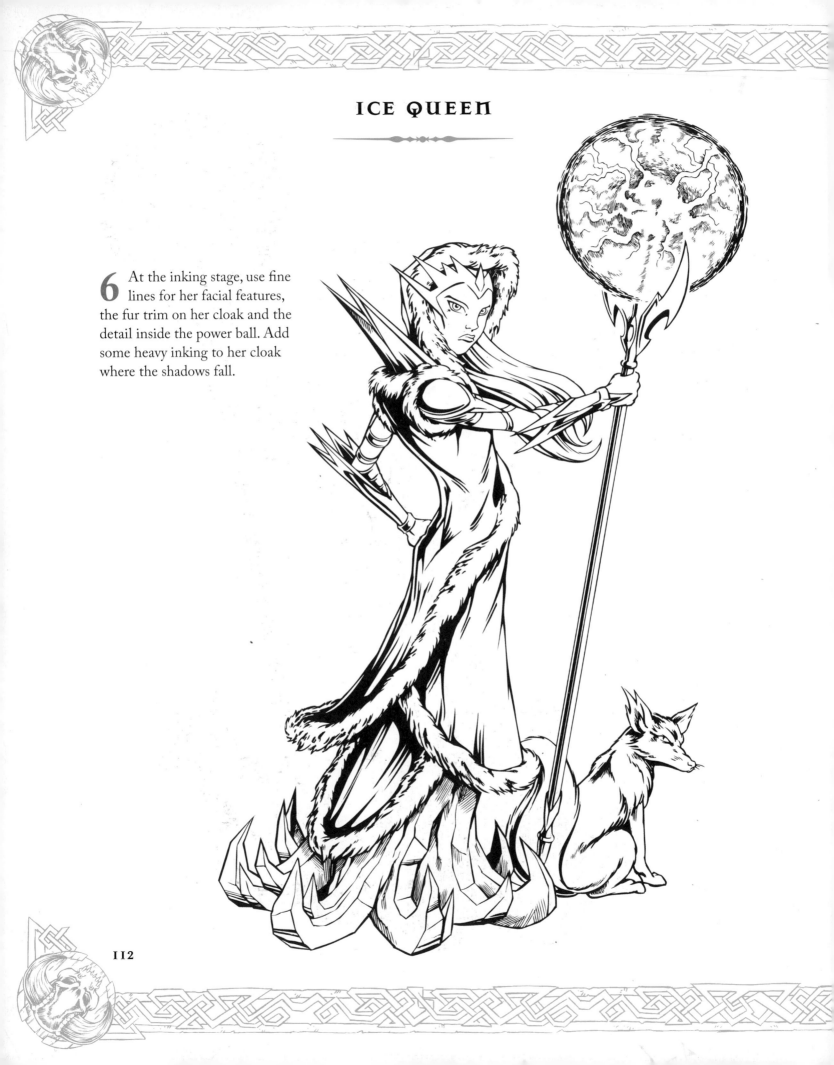

6 At the inking stage, use fine lines for her facial features, the fur trim on her cloak and the detail inside the power ball. Add some heavy inking to her cloak where the shadows fall.

ICE QUEEN

7 When you colour your ice queen, use cool blues and whites to emphasise her frostiness. Give her pale blonde hair and use a creamy white for her arctic fox. Add highlights to her face and the front of her cloak, and use shades of lilac for her power ball.

GOBLIN SHAMAN

Brandishing a flaming staff and babbling
strange incantations, the goblin shaman
leaps and dances as he conjures up the
blackest of magic. The aim of his wicked
spell is to turn the battle in favour of
the dark army.

1 This guy's a wild one! Start by
drawing a monkey-like frame
with long limbs and a short body.
The shaman is dancing, holding his
fiery staff, so raise his arms and one
of his legs. His body curves to the
right, and his head tucks down into
his body.

GOBLIN SHAMAN

2 Fill out the frame with the usual shapes, but this time, add an extra, smaller 'head' on top of the one you have already drawn as a base for the skull on his headdress. Also draw his distinctive goblin ears.

3 Once you have the basis for your goblin in place, remove your wire frame and start filling him out. Add horns to the skull headdress and define the goblin's ears. Plot the basic outline of his tunic and draw his staff with a flame coming from its tip.

GOBLIN SHAMAN

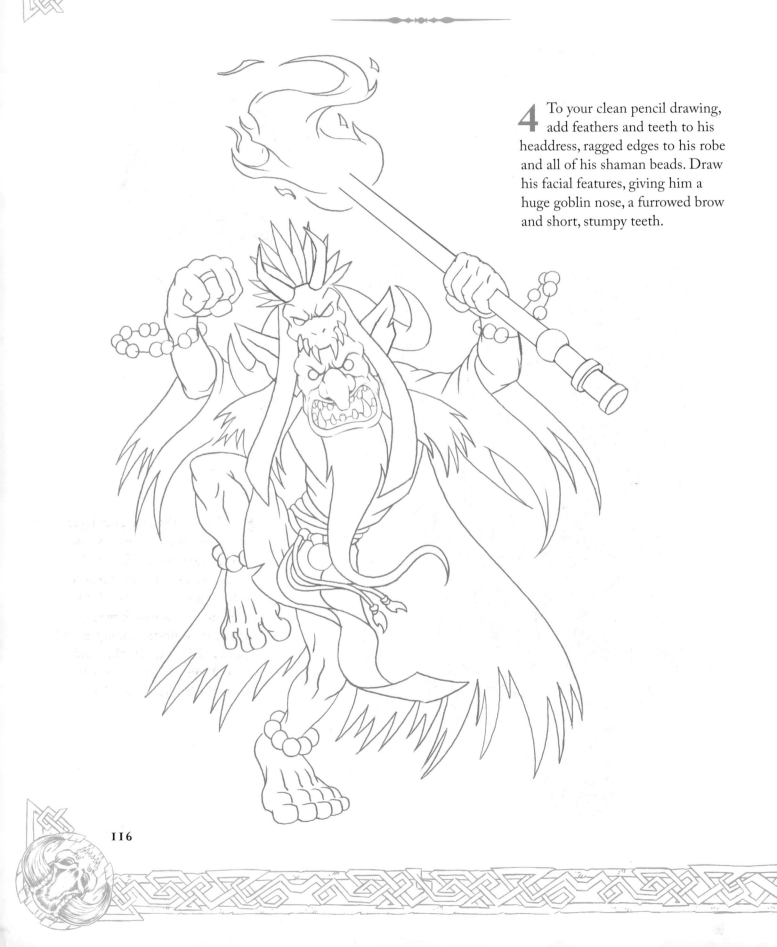

4 To your clean pencil drawing, add feathers and teeth to his headdress, ragged edges to his robe and all of his shaman beads. Draw his facial features, giving him a huge goblin nose, a furrowed brow and short, stumpy teeth.

GOBLIN SHAMAN

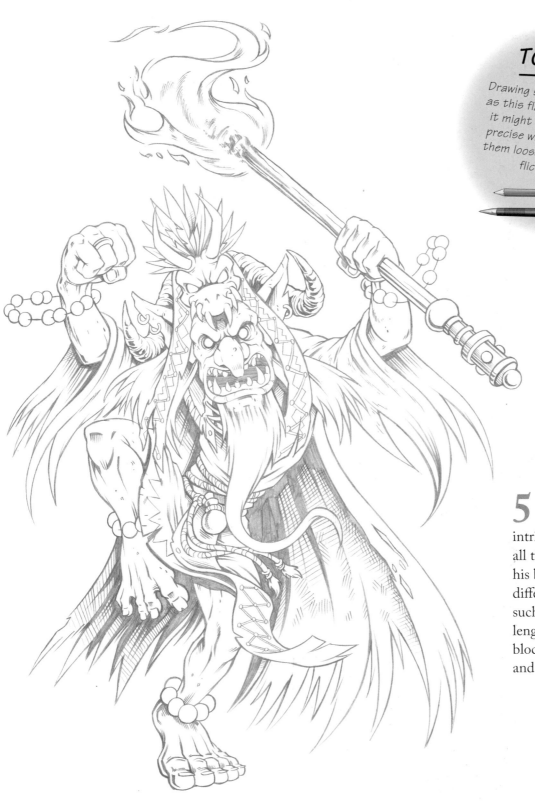

TOP TIP!

Drawing special effects, such as this flame, is simpler than it might seem. Don't be too precise with your lines. Keep them loose to create a hazy, flickery effect.

5 Now it's time to really layer up on detail, adding lots of intricate line work. Add detail all the way from his headdress to his broken toenail. Note all the different lines in this drawing, such as the different strengths and lengths of line on his robe. Add block shading inside his mouth and to the inside of his robe.

6 As the goblin is a very detailed character, try to keep your inking light and precise so as not to lose too much of your pencil detail. Only use solid inking where his body meets his robes, and inside his mouth, where the shadow is darkest.

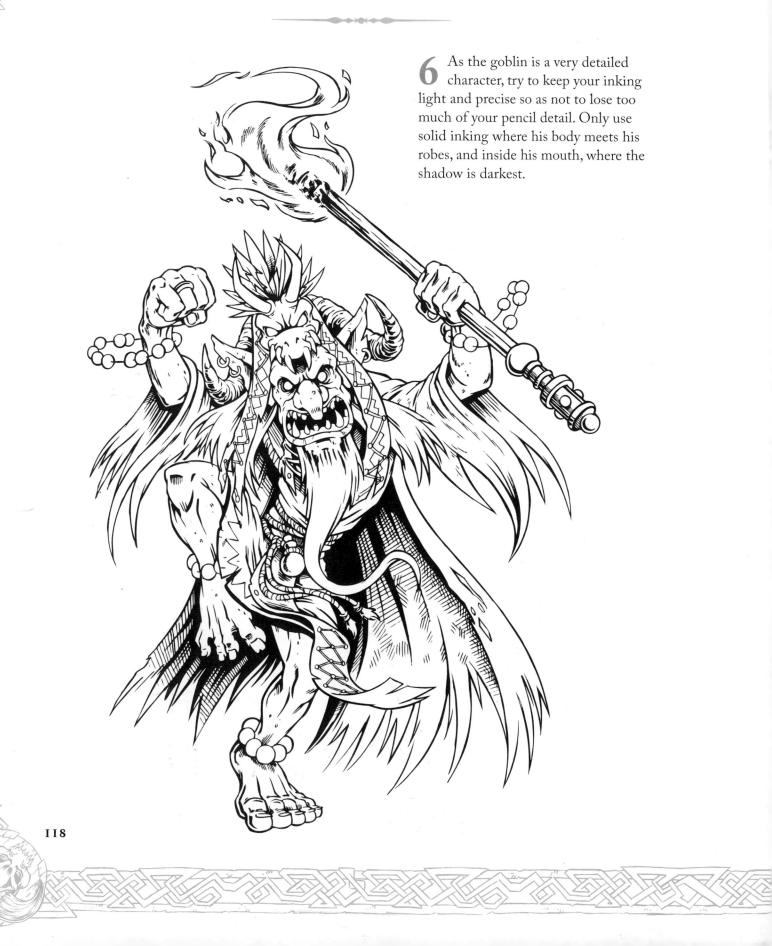

GOBLIN SHAMAN

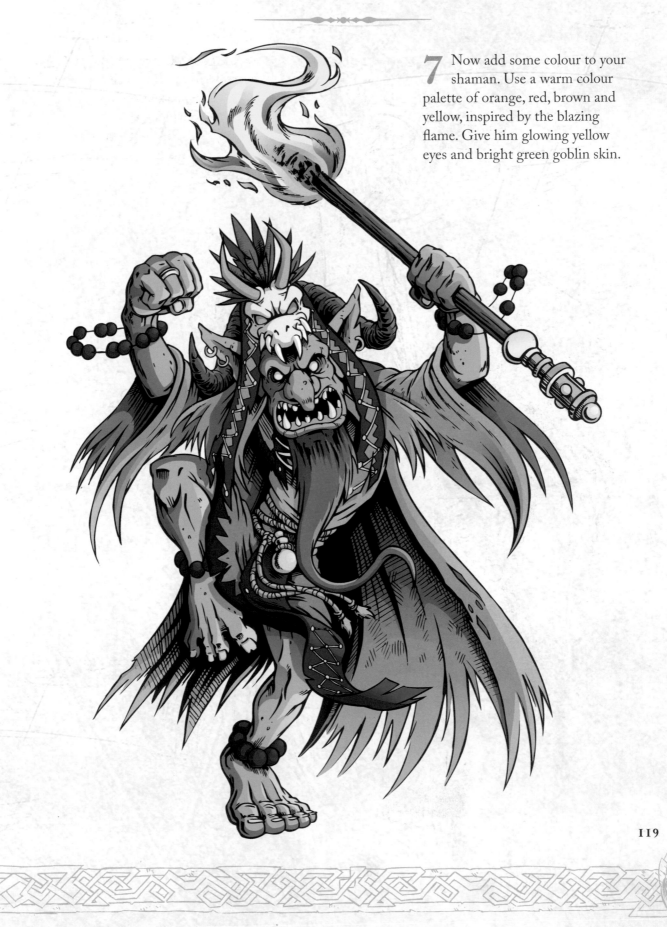

7 Now add some colour to your shaman. Use a warm colour palette of orange, red, brown and yellow, inspired by the blazing flame. Give him glowing yellow eyes and bright green goblin skin.

DEMON LORD

After an eternity of sleep deep in the abyss, the demon lord has risen. Driven by despair, and feeding on the fear of his victims, he strides forth into the world to destroy all that is good, and any brave enough to stand against him.

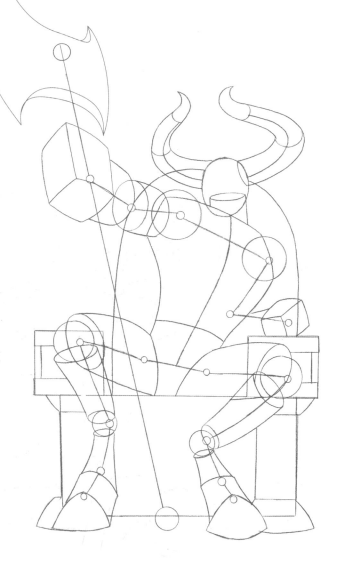

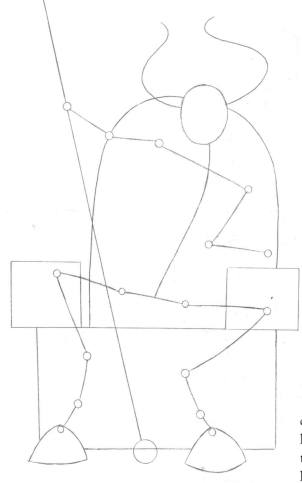

1 Start by drawing your wire frame. To demonstrate the demon lord's power we're going to show him sitting on his throne.

2 Build up your figure using basic shapes. He is leaning back in his throne, and his right arm and weapon are bigger, as they're closer to us.

DEMON LORD

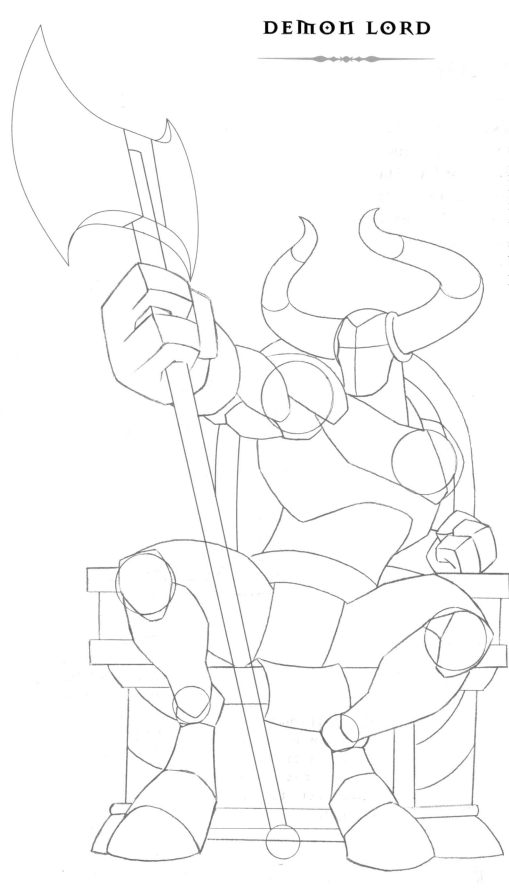

3 Using the cylinders as a base, mark in the basic sections of the body. Draw his powerful legs and chest, his horns, weapon and clenched fists. Start to work into his throne a bit more. Form the shape of the base, seat and back. Remove your frame lines as it all takes shape.

DEMON LORD

4 Once you have your outline in place, erase all of your construction lines until you have a clean pencil drawing. Now add detail. Decorate his stone throne, define his muscles, and draw in his clothing. Give him an expression of contempt and evil – the meaner the better!

DEMON LORD

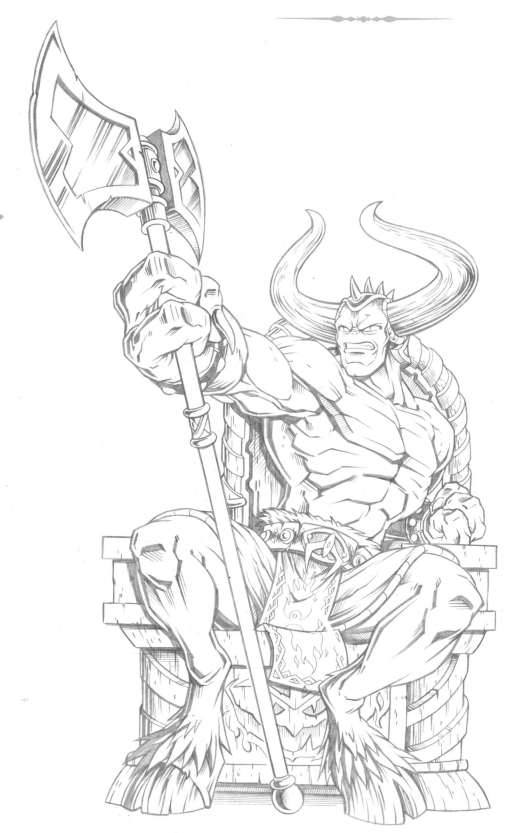

TOP TIP !

Hands can be tricky. Try clenching your own hands into fists, and then study them as a reference for your drawing.

5 At the final pencil stage, refine the lines you have and layer up even more detail. Little chips in the stone work make the chair look solid, and enhance the texture. Add the grain lines to his horns and hooves, and decorate his throne and clothing. Finally, add shading, which will really define his enormous muscles.

DEMON LORD

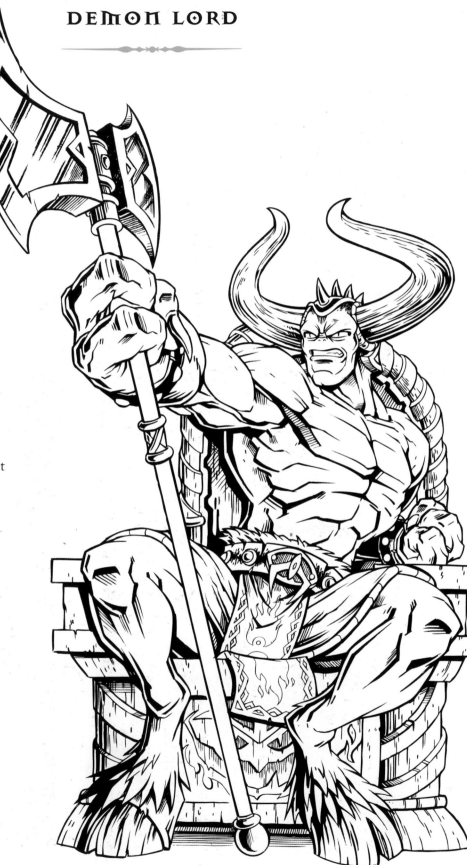

6 When inking, add solid black to the areas where the demon lord makes contact with the chair. Also use a heavy ink line to make his muscles stand out, then use thinner lines to keep all the fine details in place.

DEMON LORD

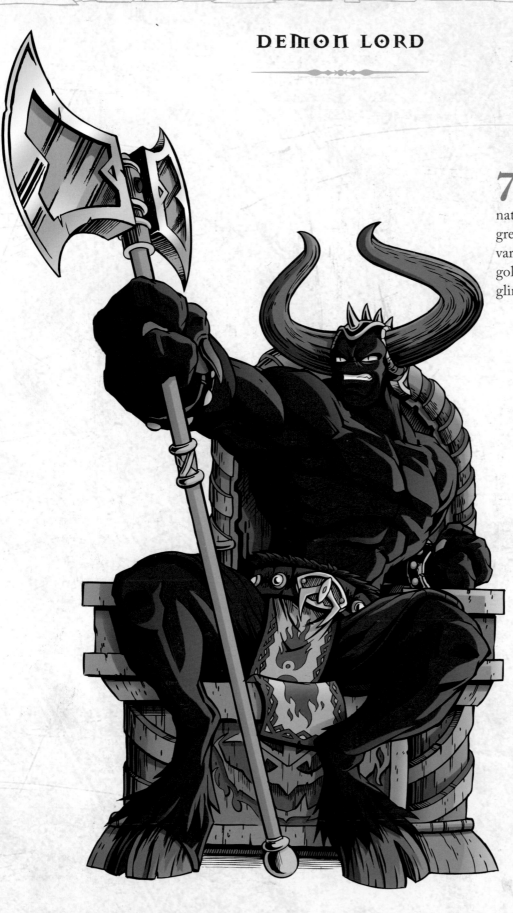

7 Fiery reds and golds will help emphasize the evil nature of the demon lord. Use greys for his throne and choose various light and dark shades of gold on his weapon to make it glint and gleam.

Drawing Force Fields

A force field is a protective barrier of energy, used to deflect enemy spells. They are as useful in battle as they are dramatic on the page, so here's a step-by-step guide on how to draw this special effect.

GLOWING FORCE FIELD

2 Now, using the neat outer circle as your guide, surround the inner circle with clusters of small, different sized balls.

1 Time to create some magic. Start by drawing a sketchy circle around the hand, then draw another neater circle surrounding the first.

3 Use luminous, colours and hazy shading to colour your force field, giving it a supernatural glow.

COMBINING EFFECTS

Here we can see how effects can be combined within a scene. Here, the ice queen's surge of magic is being blocked by the warrior's sword. An explosion of light shows the moment of impact between the two magical forces.

Drawing Fire

Drawing a blazing fire looks really effective on the page, especially once it's been coloured up. Follow the steps below to learn how. Keep your lines loose and sketchy to capture the ever-flickering movement of the flames.

BLAZING FIRE

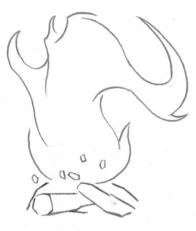

1 First, mark in the outline of the fire. Don't worry about being too exact as fire is a very wild and loose element. Not being too precise at this stage will help you allow the fire to flow.

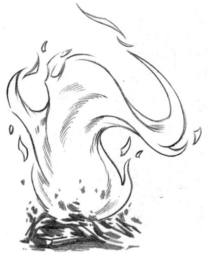

2 Now add some smudgy shading. Drawing some floating flickers around the main flame will bring movement to the fire.

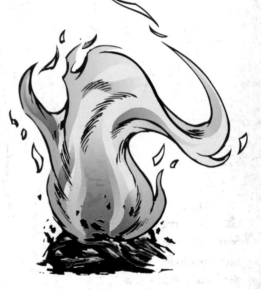

3 Add some black ink on top of your pencil lines then colour your fire. The bottom centre should be red with heat, blending into deep orange and warm yellow at the top.

TOP TIP !

Remember to give your characters fierce action poses and strong expressions when you draw them in combat.